The philosophy of offloading

HYE JA MOON

KB010707

서문당

〈Composition-비움의 철학〉 (2018)에 관한 짧은 생각들

조소영 평론가

〈Music for charms of the night sky 005〉(2016), 〈The Sun series〉(2017), 〈Composition series〉 소품 (2017)에 이어서 대작 〈Composition- 부제: 비움의 철학〉(2018)을 봉해 문혜사 작가가 보여주는 빛에 관한 철학

지난 3년간 작가 문혜자의 작품은 하나의 주제인 빛으로 같은 듯 다른 듯, 캔버스 위에 다양한 시점과 색채를 펼쳐 왔다. 해마다 빛에 관한 작가의 천착을 따라잡는 것 또한 나에겐 늘 새로운 도전이었다. 작가의 가장 최근 작품이라고 할 수 있는 〈Composition -부제: 비움의 철학〉(2018)은 작가가 지난 몇 년간 화두로 삼았던 빛, 몇 년 전 작업실에서 집으로 향하던 작가의 눈과 조우했던 가로등 불빛, 그 빛이 작가에게 불러일으켜 주었던 설렘과 기쁨의 순간을 캔버스 화면에 담으려고 했던(위에 열거한) 전작(前作)들의 묶음이자 정수이다.

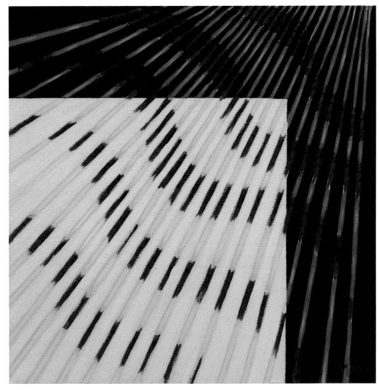

Composition 001

55×55cm Oil on Canvas 2017

문혜자 작가의 회화적 구성력은 매우 논리적이어서 작품을 구성하는 회화적 요소들을 자유자재로 더하거나 빼서 새로운 작품을 만들어낸다. 작가의 최근 작인 Composition(대작)의 부제는 "비움의 철학"이다. 전작들에서 작가가 한 일은 작품 안에 그간의 작가가 천착해 왔던 빛의 구상들을 담는 일이었다. 하지만 이 번 작품에서 작가는 빛에 관한 요소들을 아름답게 채우고 정작 광원에 관한 한, 어떤 묘사도 담지 않았다. 즉, 그리지 않아도 당당히 존재하는 광원의 실존을 드러내는 작품이라고 하겠다.

2016년의 작품 <Music for Charms of the Night Sky 005>에서 시작된 순수한 빛의 경험에서 시작된 빛을 향한 이끌림과 집중, 2017년 연작<The Sun>과 <The Light>에서 보여준 빛의 성질 가운데 1)광선은 직진한다. 2) 빛은 입자이다. 이 두 가지 빛의 성질이 만들어 내는 공간적 효과, 그리고 2017년 후반부에는 composition series 소품을 통해 직진하는 광선이 색의 입자로 이루어져있으며, 그런 개별 선들이 곡면을 이루며, 화면의 분할을 통해 빛이 얼마나 다른 느낌을 줄 수 있는 시 보여준다.

지난 몇 년간, 세 가지 작품들의 구성적 요소들이 <Composition- 부제: 비움의 철학>(2018)에 고스란히 담겨 있다. 작가의 마음을 순간에 사로잡았던 광원이 이 번 작품의 중심에서 관람자의 시선을 사로잡고 있으며, 뻗어 나오거나 수렴하는 듯한 광선의 공간적 효과는 2017년 <The Light>의 것과 닮았으며, 소품 <Composition>(2017) 의 직선 면 분할이 이 번 대작에서는 곡선 분할로 변용되었다.

이렇듯 지난 3년 간의 작가의 빛에 관한 천착이 이 번 작품에 집대성 되었으면서도, 그 간 작가의 작품에 오랜 시간 등장해 왔던 이야기나 설명을 모두 내려놓았다. 화려한 색들의 조형적 이야기들은 몸을 감춘다. 작가는 '빛은 거기에 있다.'고 말하지 않는다. 그냥 '비워두었다'. 작가의 연륜과 성찰이 드러나는 부분이다.

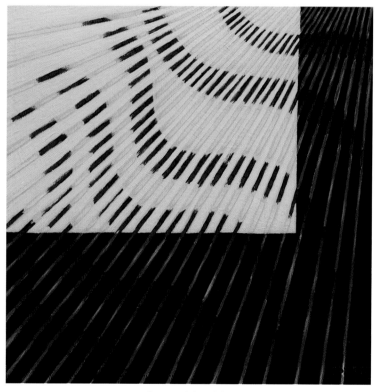

Composition 002
55×55cm Oil on Canvas 2017

⟨Composition-The philosophy of offloading⟩
2018

Soyoung Cho Art Critic

* The attachment on ⟨Composition − The philosophy of offloading⟩(2018)
* The philosophy on light dug into by Hyeja Moon through her paintings as ⟨Music for charms of the night sky 005⟩(2016), ⟨The Sun⟩ series(2017), and ⟨Composition⟩ series(2017)

* Over the past three years, Hyeja Moon has spread out various points of view and colors on the Canvas for a theme, light. Year by year, it has been a challenge for me to follow the trace of her toil on light. Hyeja Moon's recent work ⟨Composition − the Philosophy of offloading⟩(2018) is the quiescence and ensemble of her previous works into which she wanted to put the thrill and joy that she got on the way home from her studio a few years ago when a light of street lamp hit her eyes and quickened her heart beat.

* The artist Moon has a peculiar aptitude for the pictorial composition, and makes a new work by adding or subtracting pictorial elements with dexterity. The latest work of hers, ⟨Composition − the Philosophy of offloading⟩ got its subtitle on account of her attitude of light source, one of her main themes. First of all, she puts all the ideas on the light and colors on the Canvas. Then, she paints the light source out of it. It was the most impressive part of all. She has occupied herself by filling elements on the Canvas for some time. However, this time she beautifully filled the elements of light with the Canvas, but no described the light source. That is, the artist tells nothing about the light source, but it reveals itself by not describing.

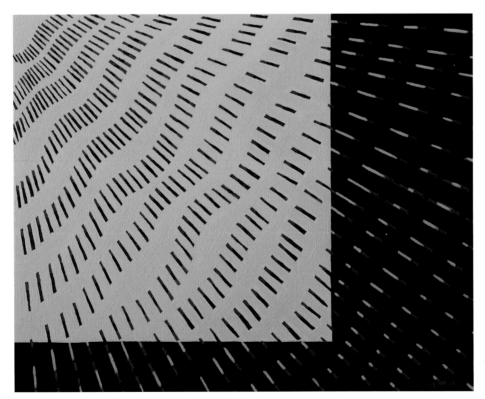

Composition, the philosophy of offloading 002
91×72.5cm Oil on Canvas 2018

＊ In 2016, Moon painted her intensive passion about light which was shown through her work ⟨Music for Charms of the Night Sky 005⟩. In 2017, serial works ⟨The Sun⟩ and ⟨The Light⟩ demonstrated the nature of light: 1) Light travels in straight lines. 2) Light particles vary. She experimented how different effects were resulted according to the ratio of the two composing elements in the small sized ⟨Composition⟩ series in 2017.

＊ After years of studying, she filled ⟨Composition − the Philosophy of offloading⟩(2018) with all the elements of past works such as ⟨The Music for Charms of the Night Sky 005⟩, ⟨The Sun⟩, ⟨The Light⟩ and ⟨Composition⟩ series(2017). The light source that had captured Moon's heart in a moment positioned in the center of ⟨Composition − the Philosophy of offloading⟩(2018). Now, it is ready to capture the viewers'. Whereas the spatial effect of convergence and spread out in the work ⟨Composition − the Philosophy of offloading⟩(2018) seems alike with ⟨The Light⟩(2017), linear division in ⟨Composition⟩series(2017) changed into circular in ⟨Composition − the Philosophy of offloading⟩(2018).

＊ This way, Moon collected all her toils about the theme of light for the last three years into this work. Nonetheless, she put all the stories and explanations away. Colorful plastic episodes hide themselves. The artist does not say, "The light is there". She just says, "Let it be". This is the part where her sagacity and experience appear.

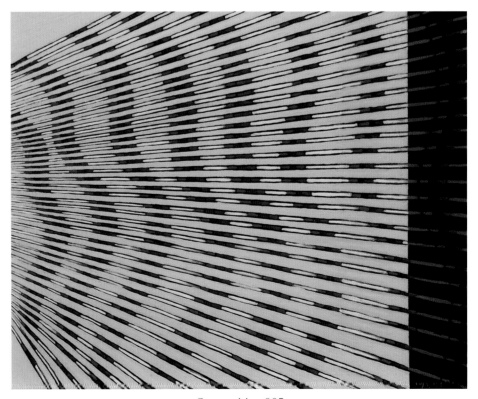

Composition 005
91×72.5cm Oil on Canvas 2017

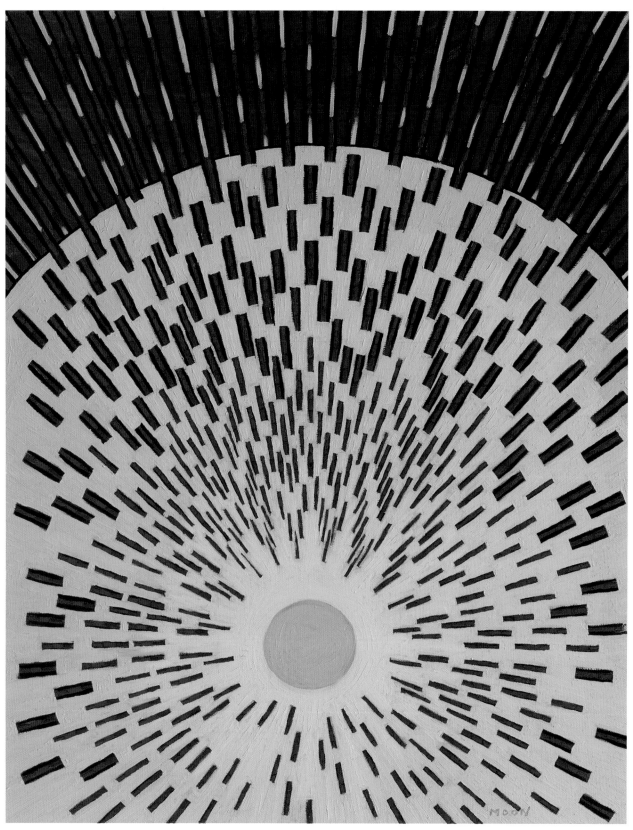

Composition, the philosophy of offloading 005
91×72.5cm Oil on Canvas 2018

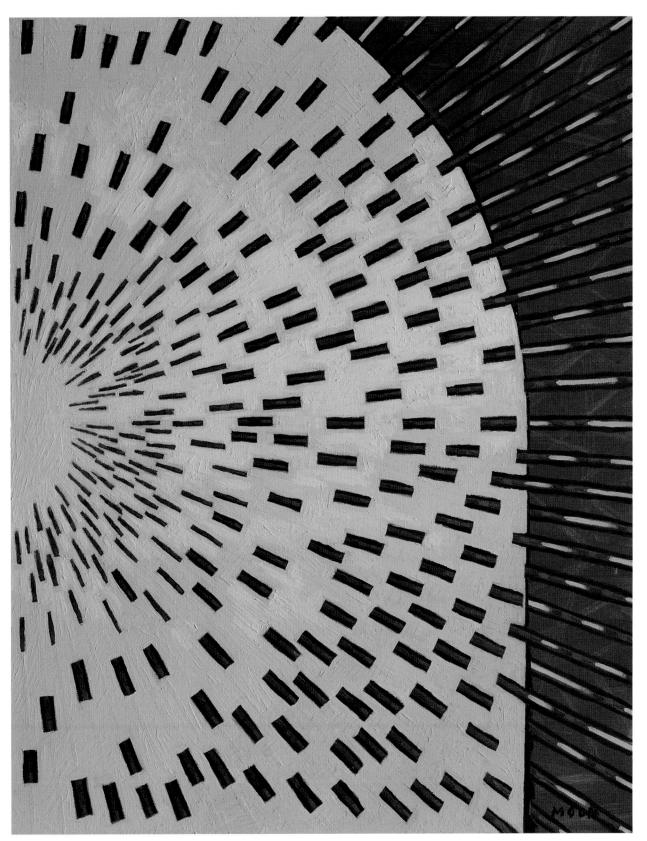

Composition, philosophy of offloading 004
91×72.5cm Oil on Canvas 2018

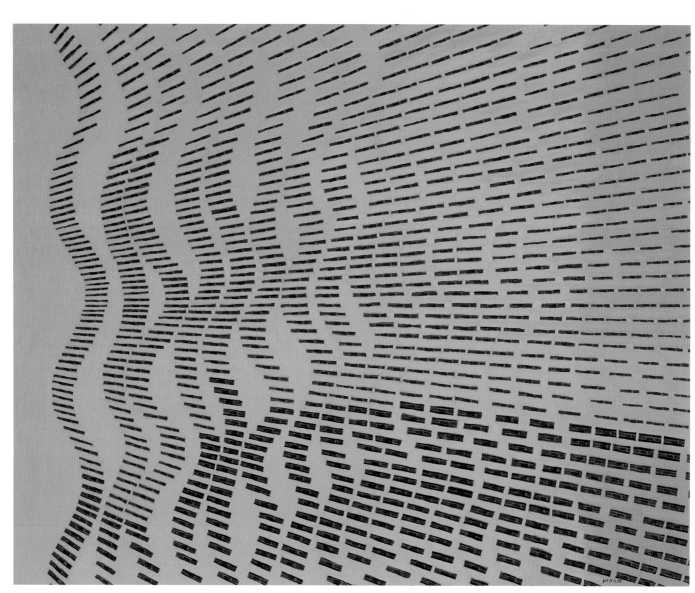

Composition the philosophy of offloading 006
162×132cm Oil on canvas 2018

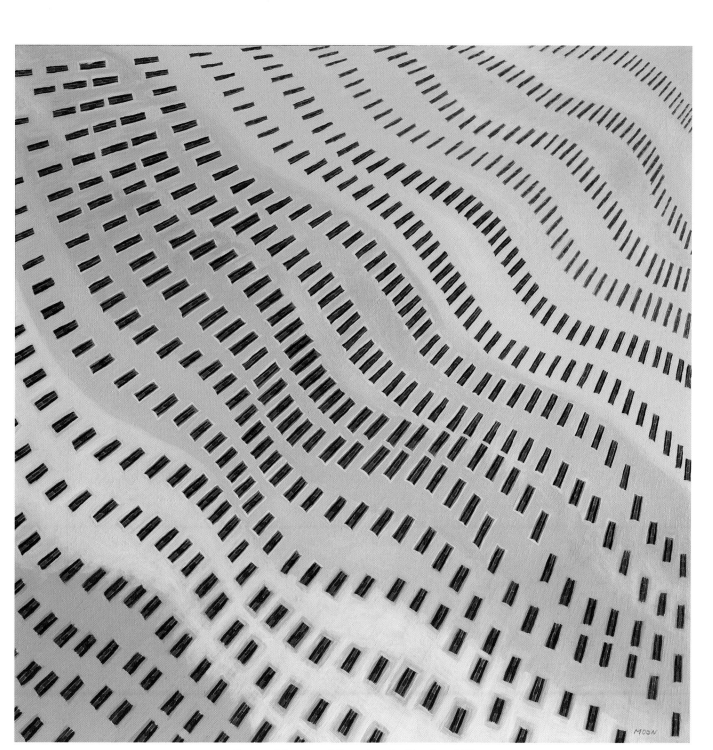

Composition the philosophy of offloading 007
150×150cm Oil on canvas 2018

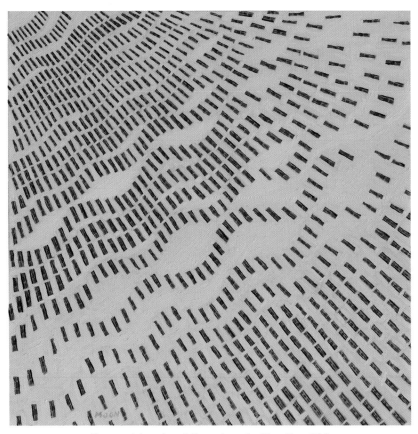

Composition the philosophy of offloading 008
74×74cm Oil on canvas 2018

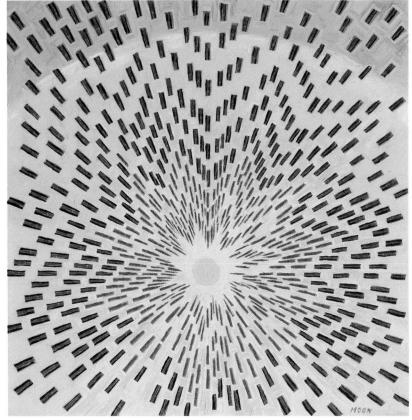

Composition the philosophy of offloading 010
74×74cm Oil on canvas 2018

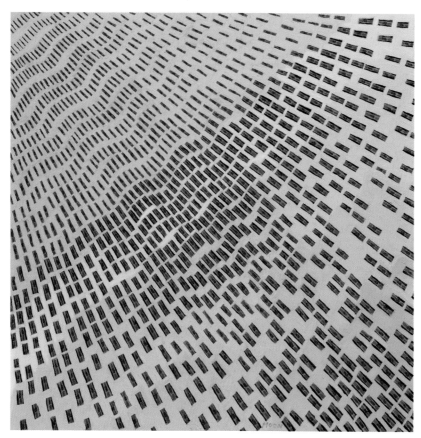

Composition the philosophy of offloading 009
74×74cm Oil on canvas 2018

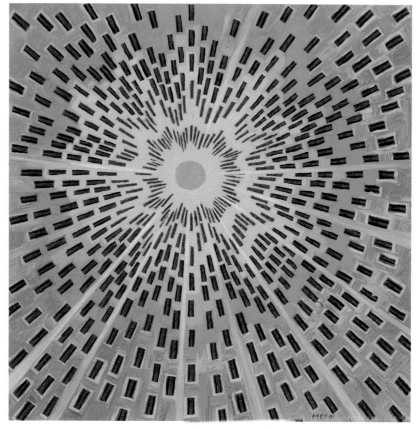

Composition the philosophy of offloading 011
74×74cm Oil on canvas 2018

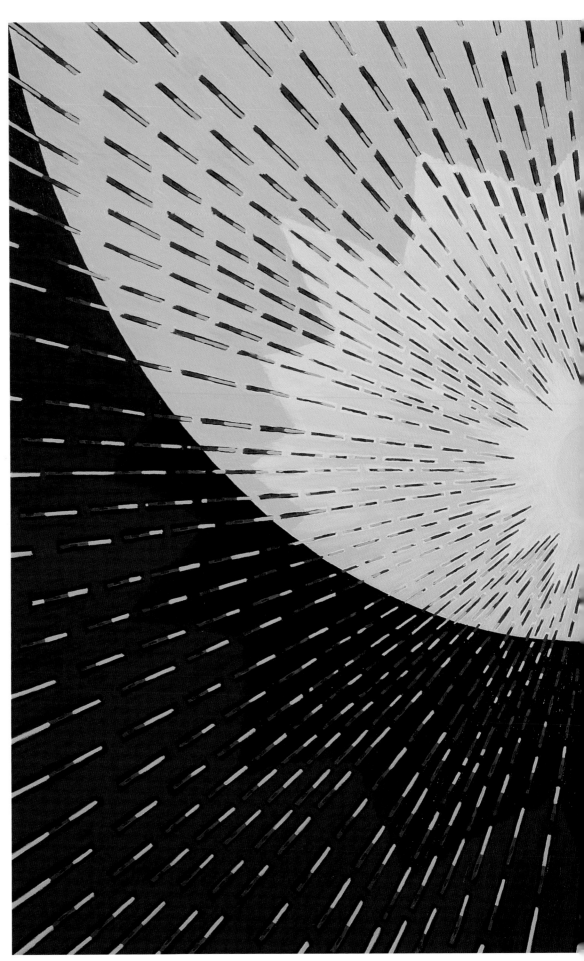

Composition, the philosophy of offloading 001
260×194cm Oil on Canvas 2018

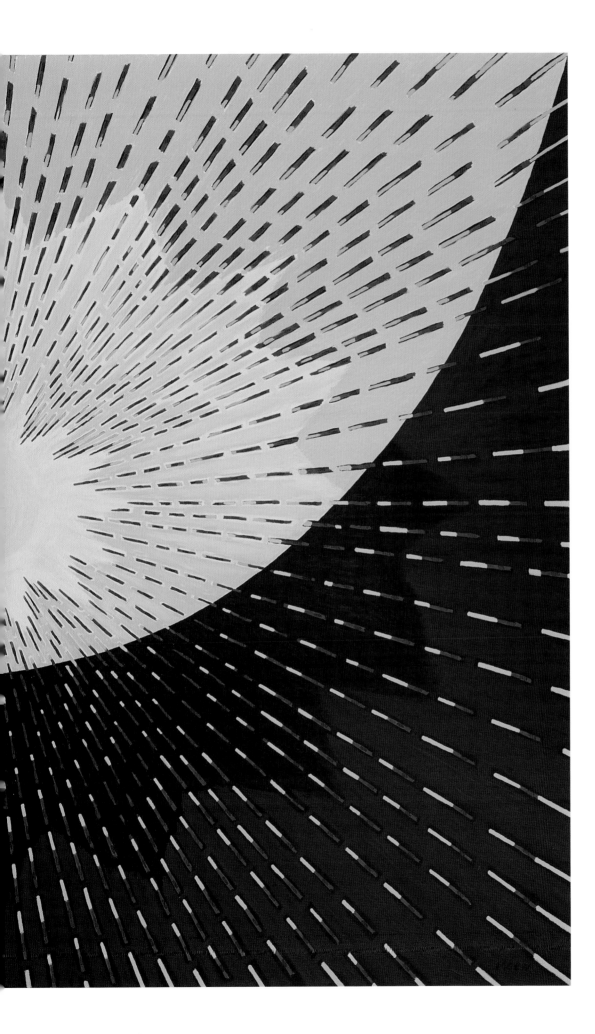

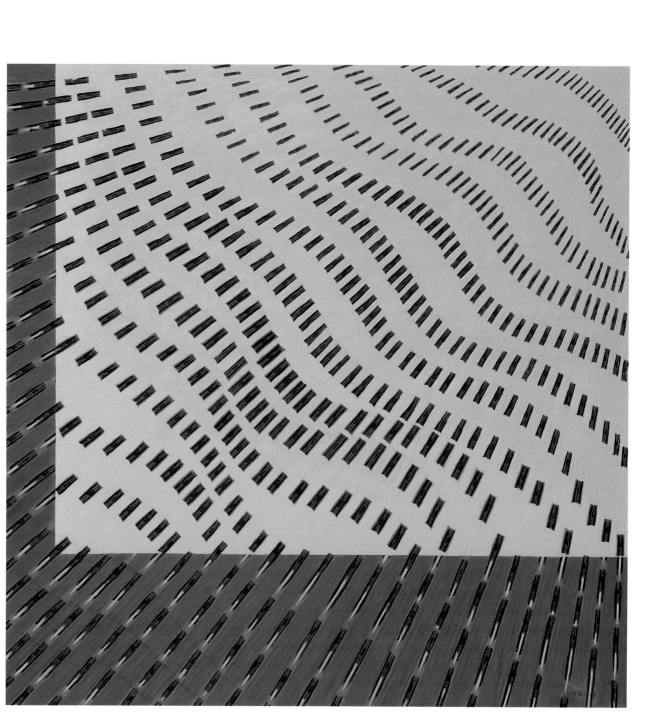

Composition, the philosophy of offloading 003
150×150cm Oil on Canvas 2018

Composition 004
91×72cm Oil on Canvas 2017

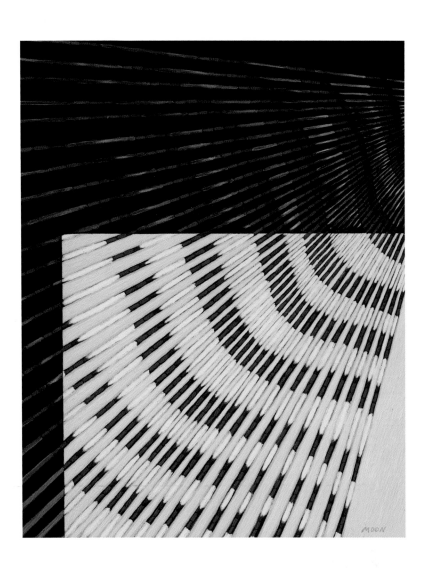

Composition 003
55×55cm Oil on Canvas 2017

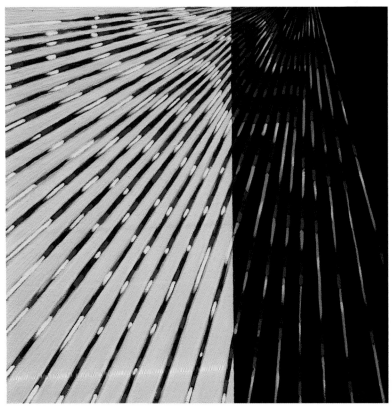

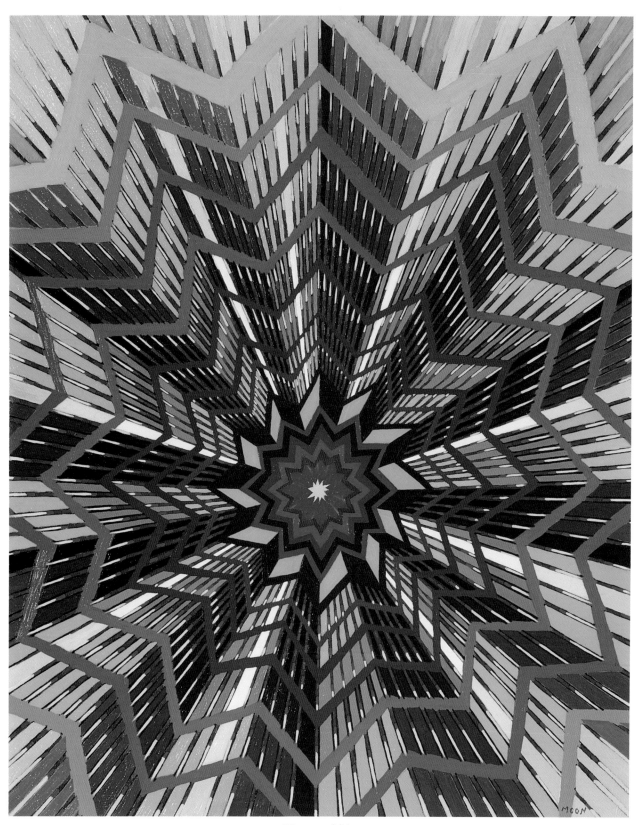

The sun 001
162×132cm Oil on Canvas 2017

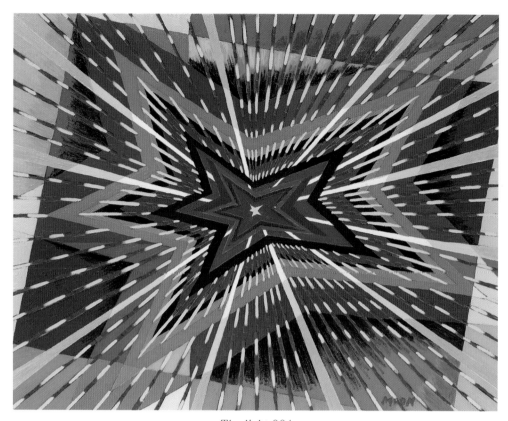

The light 004
91×72cm Oil on Canvas 2017

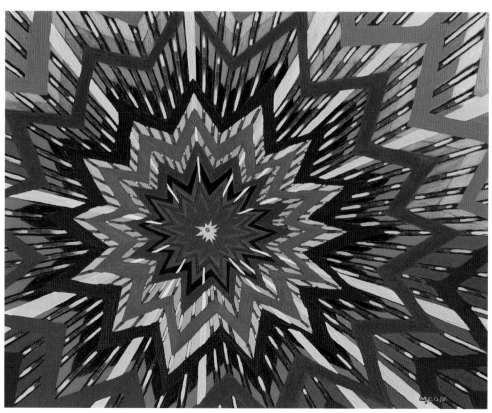

The light 005
91×72cm Oil on Canvas 2017

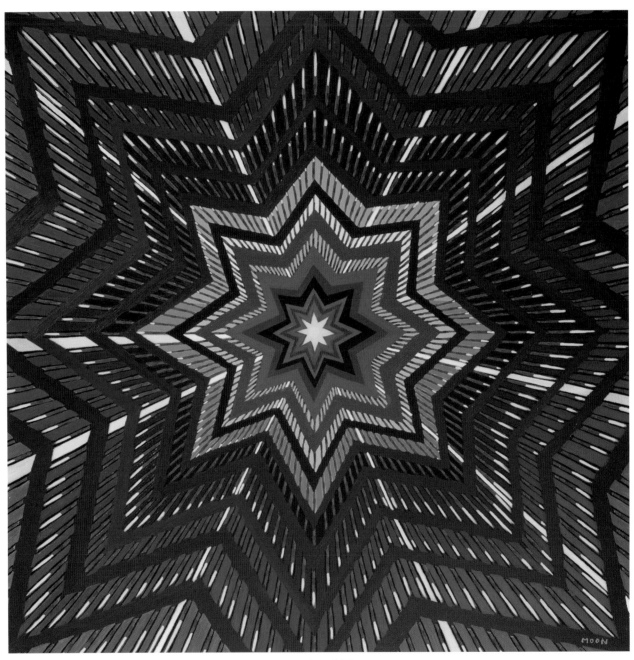

The light 006
150×150cm Oil on Canvas 2017

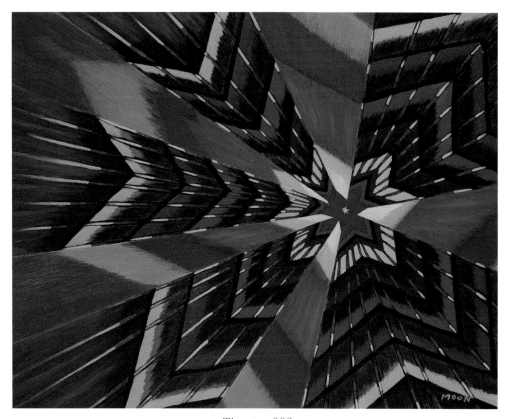

The star 002
91×72.5cm Oil on Canvas 2017

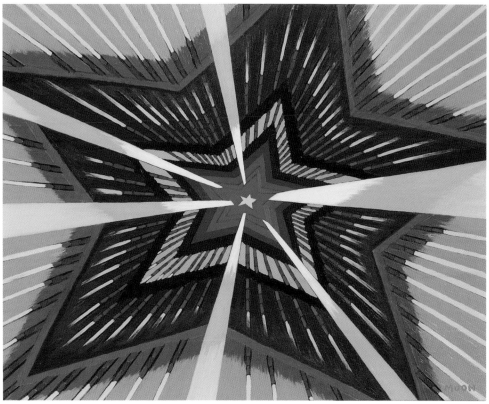

The star 001
91×72cm Oil on Canvas 2017

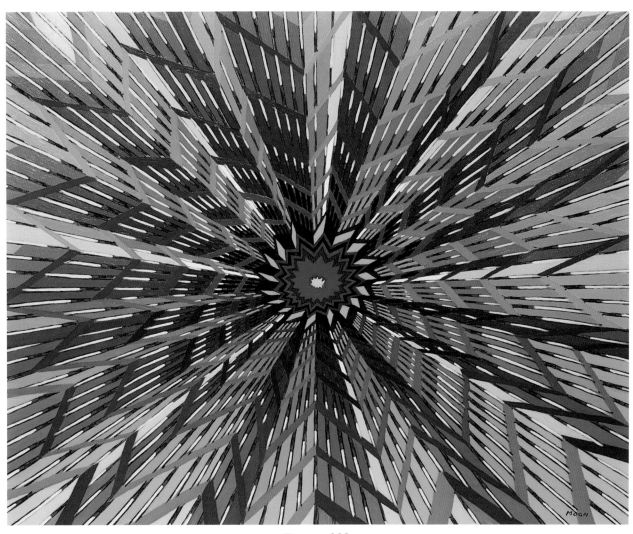

The sun 002
162×130cm Oil on Canvas 2017

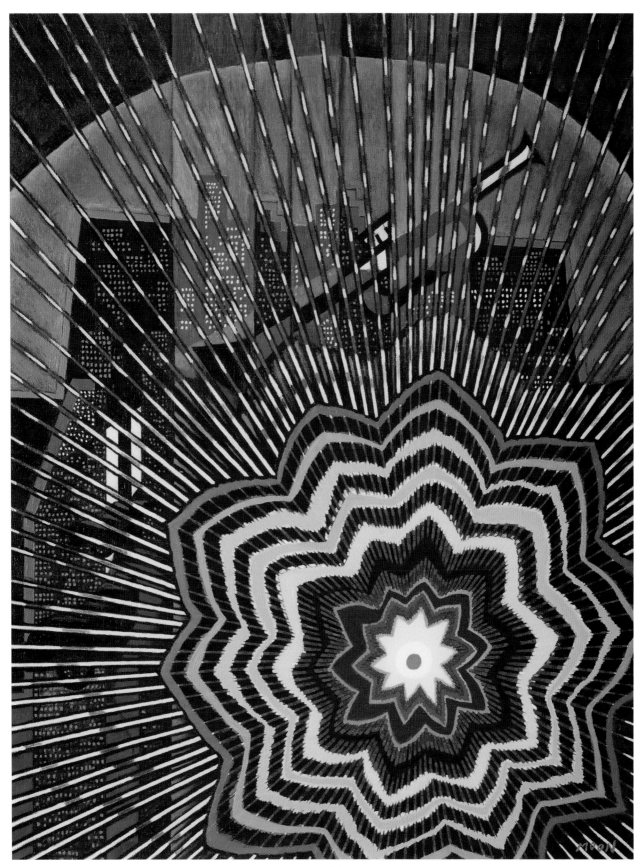

Headlight
132×160cm Oil on Canvas 2016

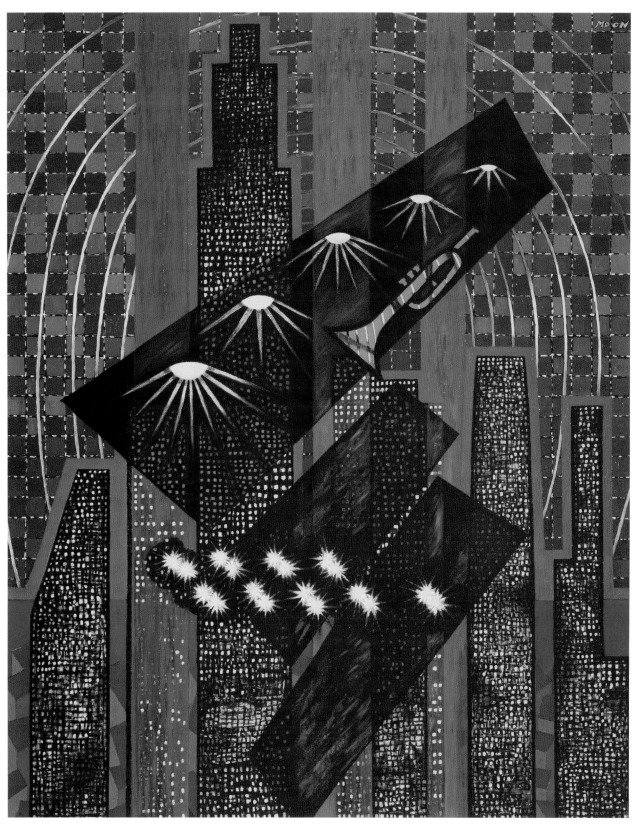

Music for charms of the night sky 003

132×160cm Oil on Canvas 2016

Music for charms of the night sky 004
55×55cm Oil on Canvas 2016

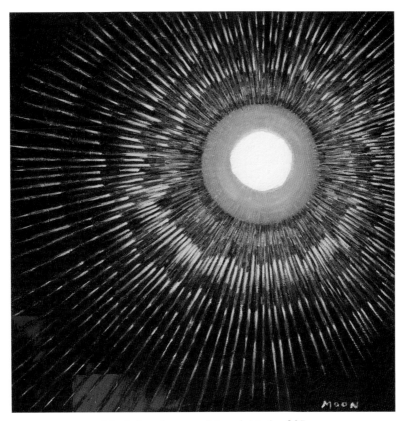

Music for charms of the night sky 005
55×55cm Oil on Canvas 2016

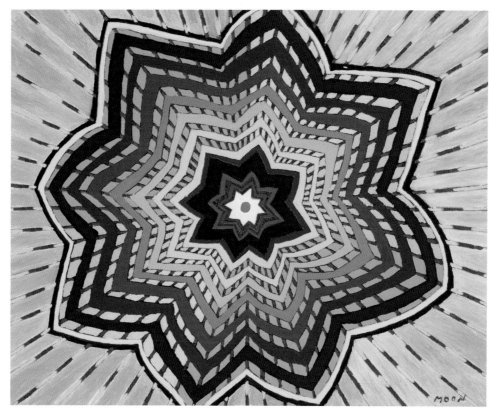

The light 001
91×72.5cm Oil on Canvas 2016

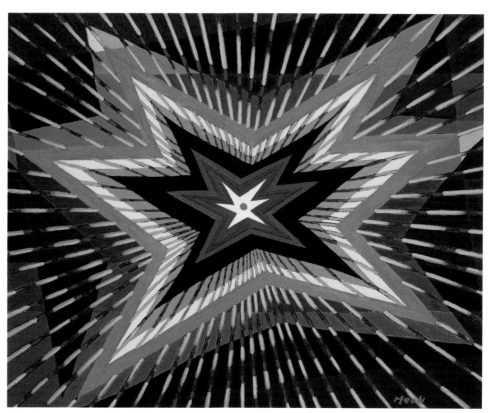

The light 002
91×72.5cm Oil on Canvas 2016

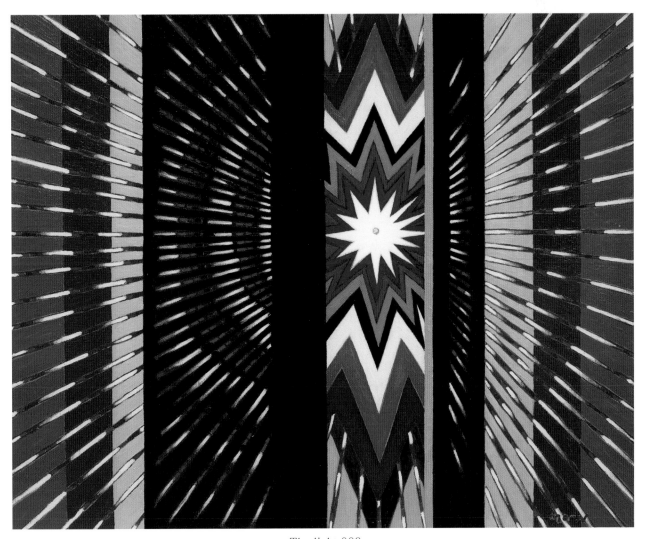

The light 003
91×72cm Oil on Canvas 2016

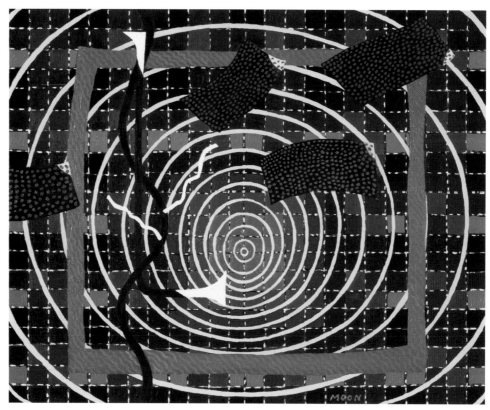

Music for beautiful sunset 002
91×73cm Oil on Canvas 2015

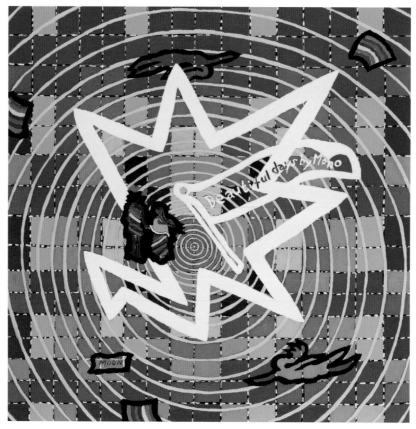

Music for Beautiful Days(1502)
72×72cm Oil on Canvas 2015

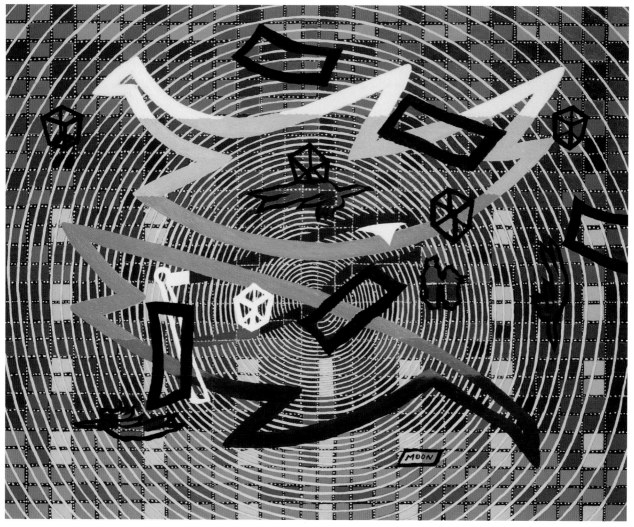

Music for beautiful Days(1504)
162×130cm Oil on Canvas 2015

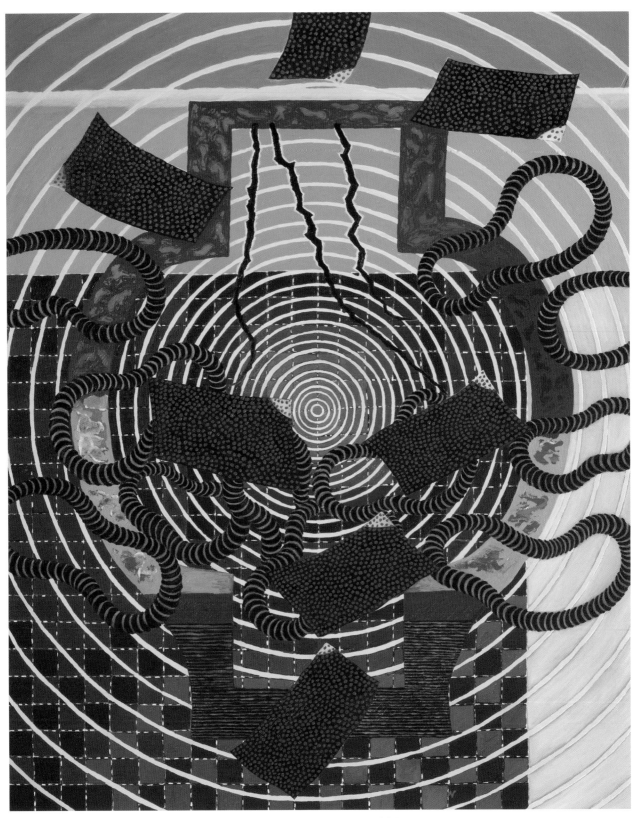

Music for beautiful sunset 004
130×162cm Oil on Canvas 2015

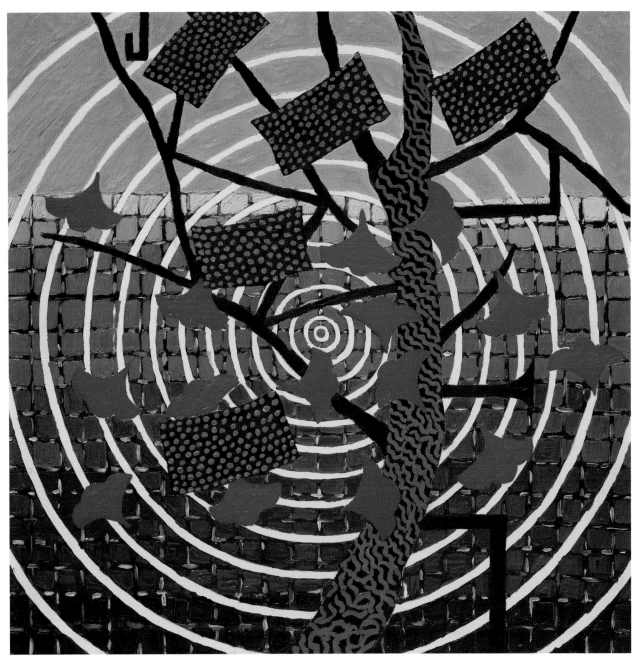

Music for beautiful sunset 005
55×55cm Oil on Canvas 2015

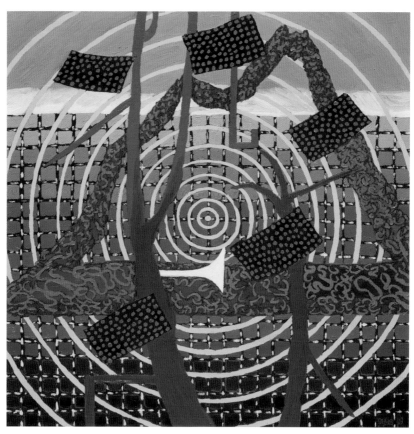

Music for beautiful sunset 006
55×55cm Oil on Canvas 2015

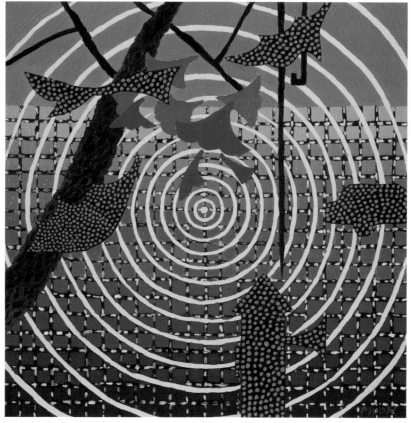

Music for beautiful sunset 007
55×55cm Oil on Canvas 2015

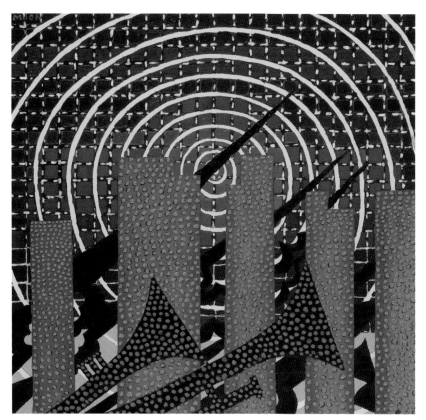

Music for beautiful sunset 008
55×55cm Oil on Canvas 2015

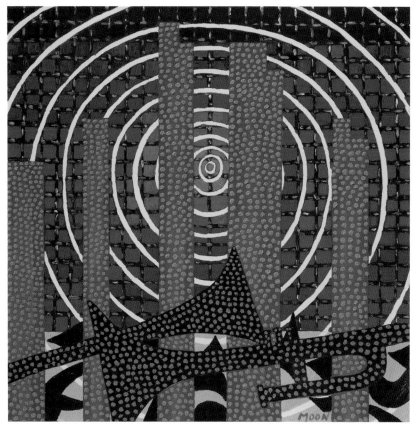

Music for beautiful sunset 009
55×55cm Oil on Canvas 2015

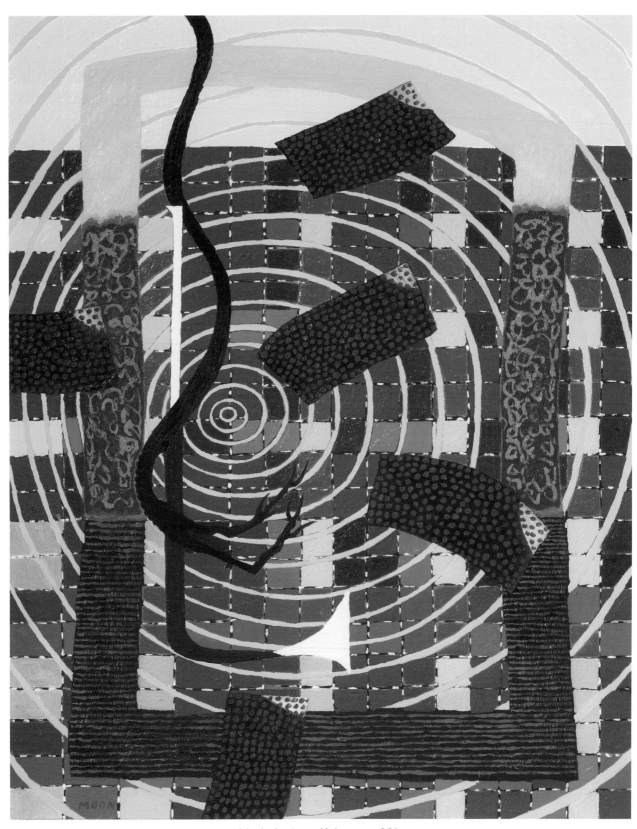

Music for beautiful sunset 001

73×91cm Oil on Canvas 2015

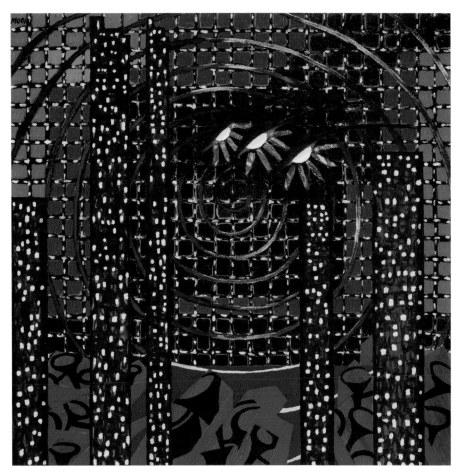

Music for charms of the night sky 001
55×55cm Oil on Canvas 2015

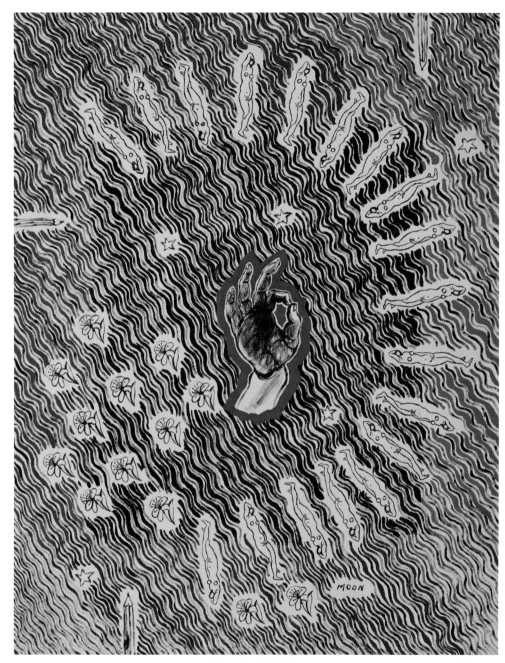

Drawing(1401)
91×116.8cm Oil on Canvas 2014

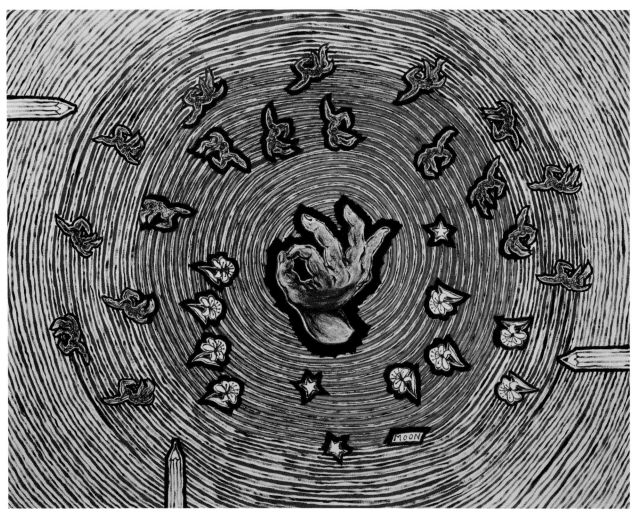

Drawing(1402)
116.8×91cm Oil on Canvas 2014

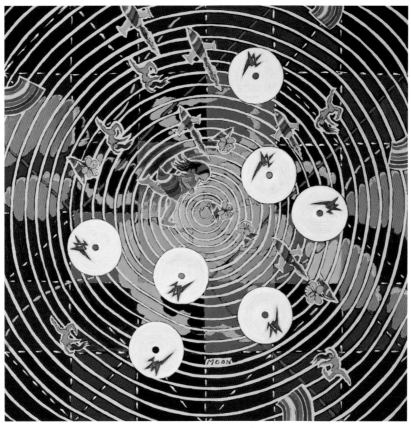

Music for Ending Story(1401)
90×90cm Oil on Canvas 2014

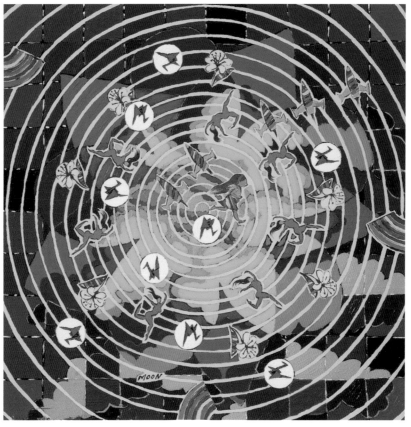

Music for Ending Story(1405)
70×70cm Oil on Canvas 2014

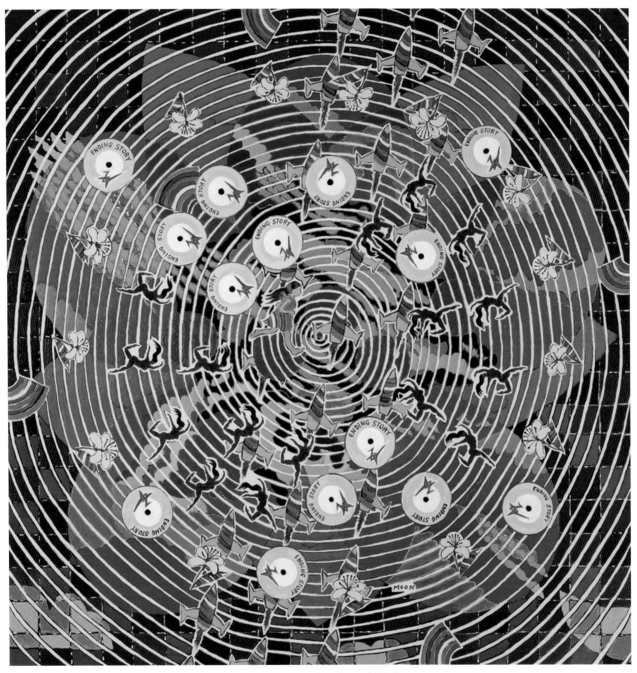

Music for Ending Story (1406)
150×150cm Oil on Canvas 2014

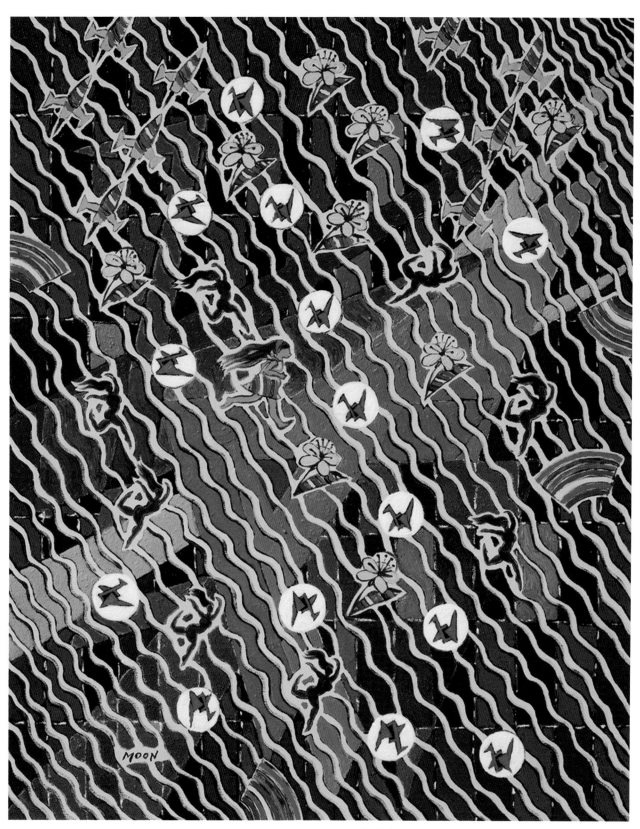

Music for Ending Story(1407)
73×91cm Oil on Canvas 2014

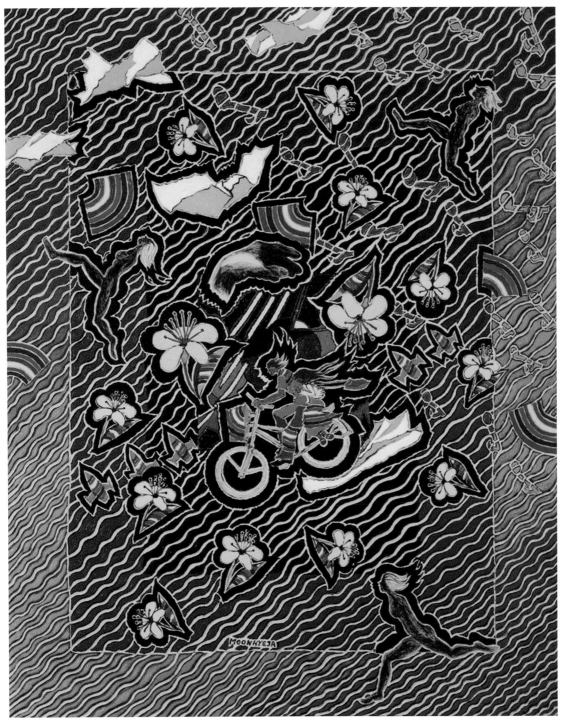

Master Music for Bohemian Purgatory(1302)
65×65cm Oil on Canvas 2013

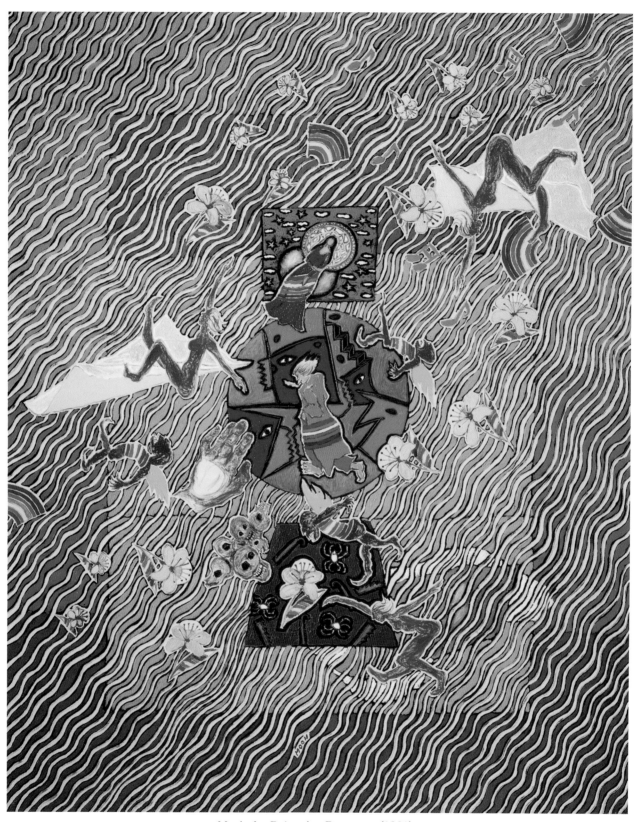

Music for Bohemian Purgatory (1301)
130×162cm Oil on Canvas 2013

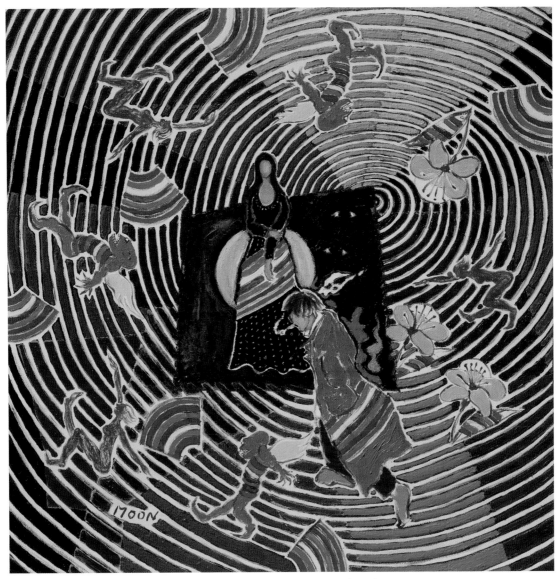

Music for Bohemian Purgatory (1303)
65×65cm oil on Canvas 2013

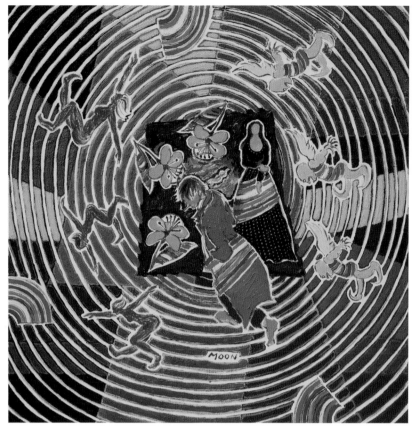

Music for Bohemian Purgatory(1305)
65×65cm Oil on Canvas 2013

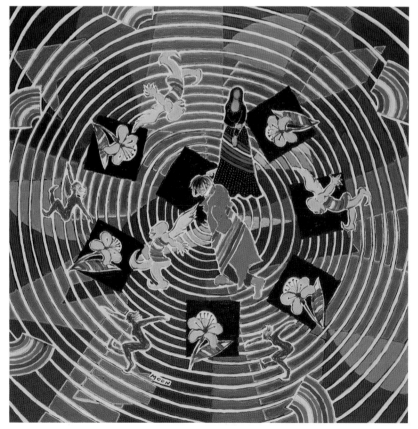

Music for Bohemian Purgatory(1307)
90×90cm Oil on Canvas 2013

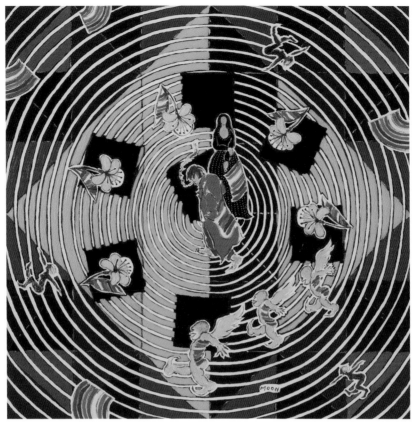

Music for Bohemian Purgatory(1308)
90×90cm Oil on Canvas 2013

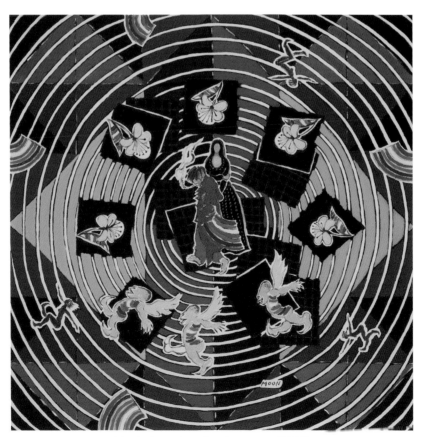

Music for Bohemian Purgatory(1309)
90×90cm Oil on Canvas 2013

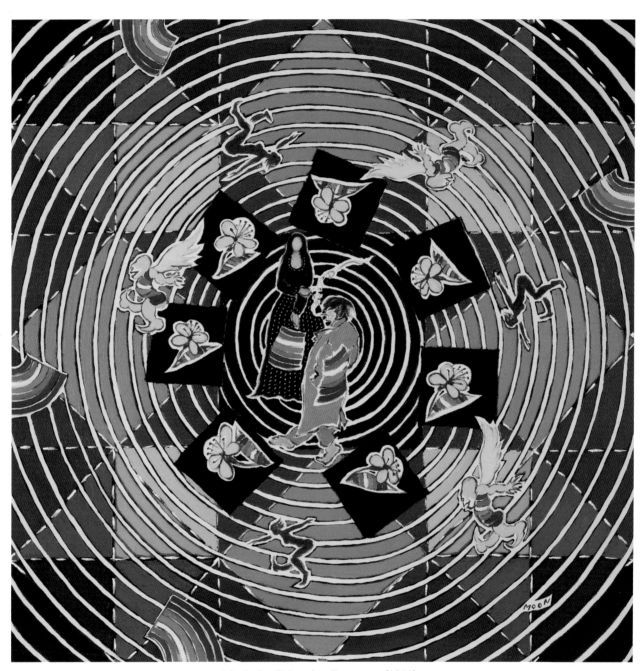

Music for Bohemian Purgatory(1311)
90×90cm Oil on Canvas 2013

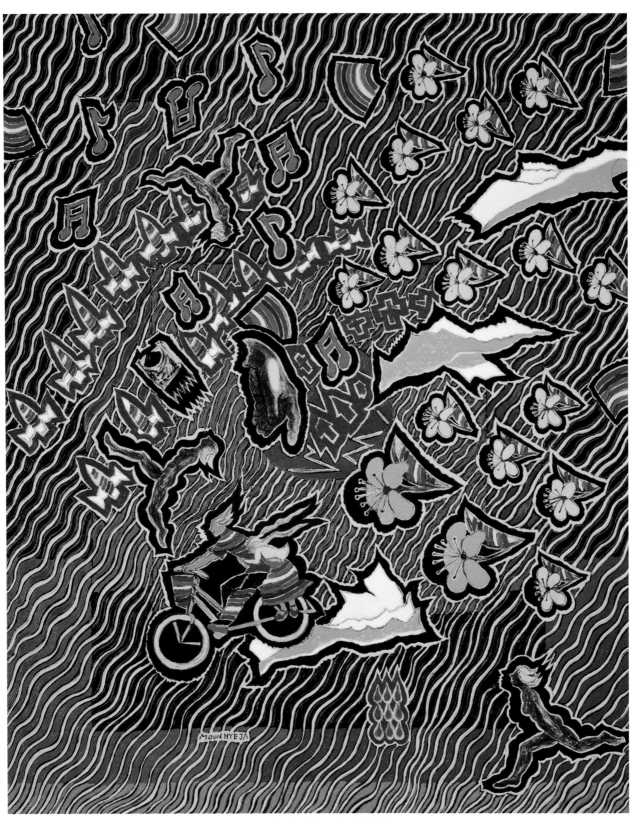

Music for Yearning(1206)
162×130cm Oil on Canvas 2012

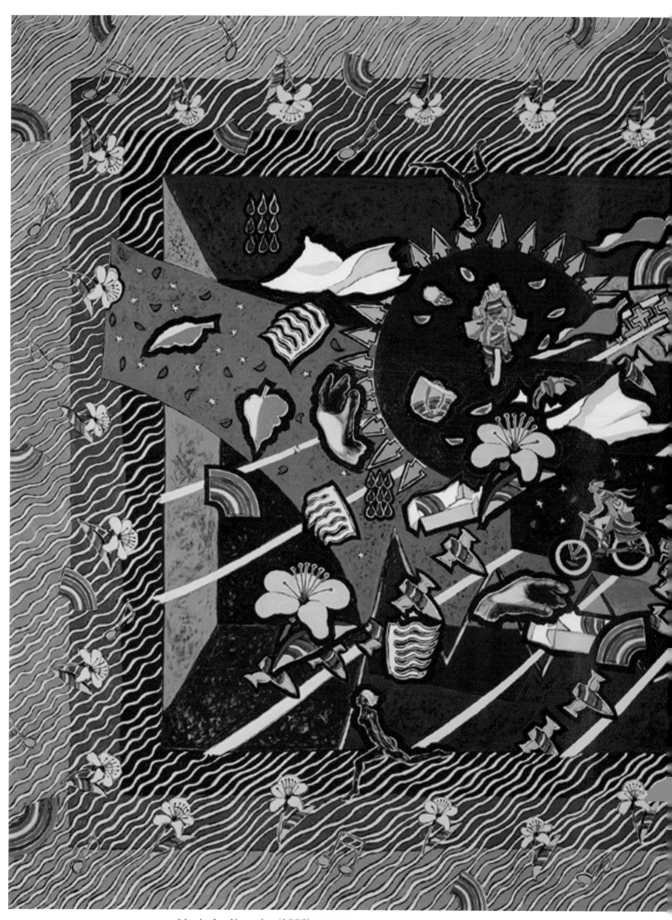

Music for Yearning(1203) 365×227cm Oil on Canvas 2012

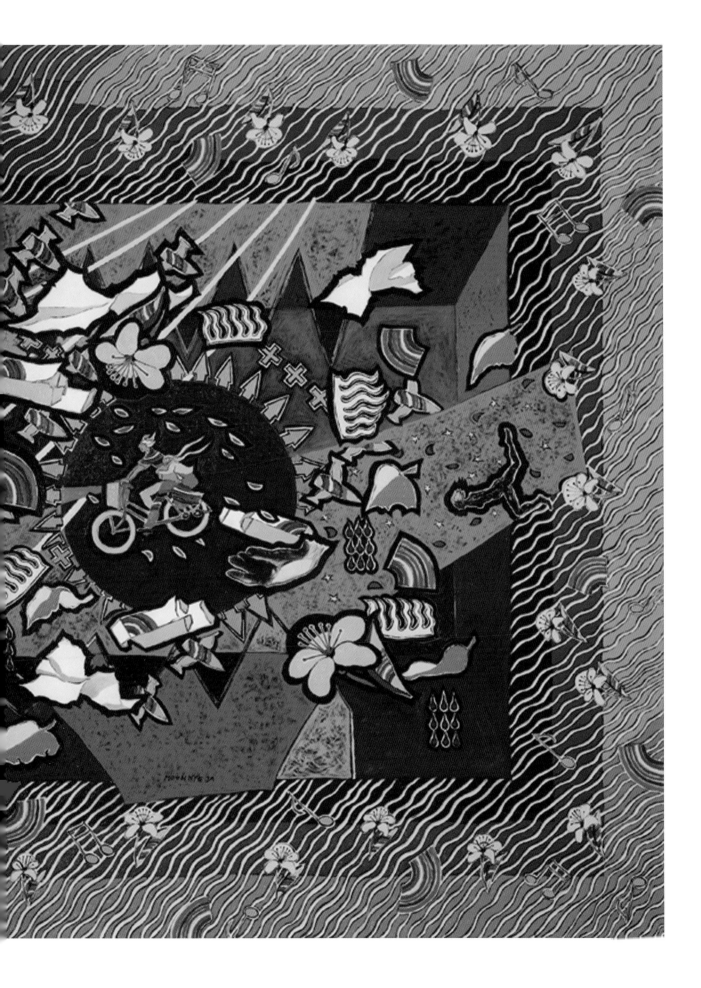

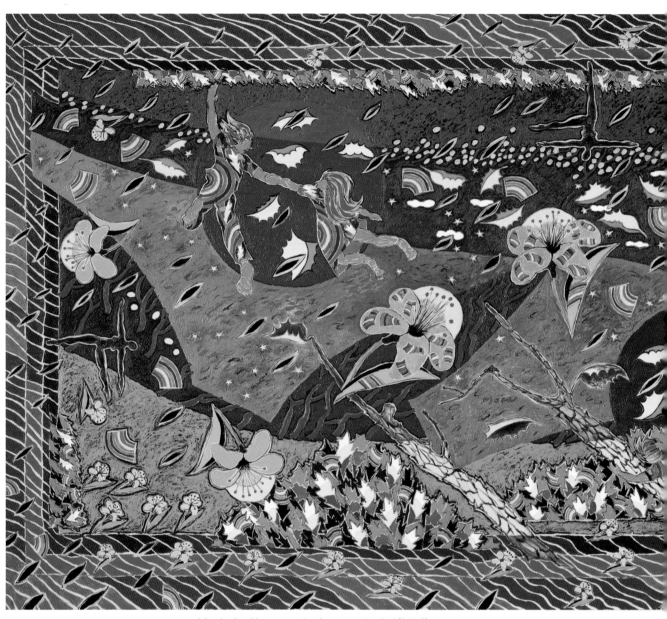

Music for Hymn to the immortal wind(1112)
486.6×192cm Oil on Canvas 2011

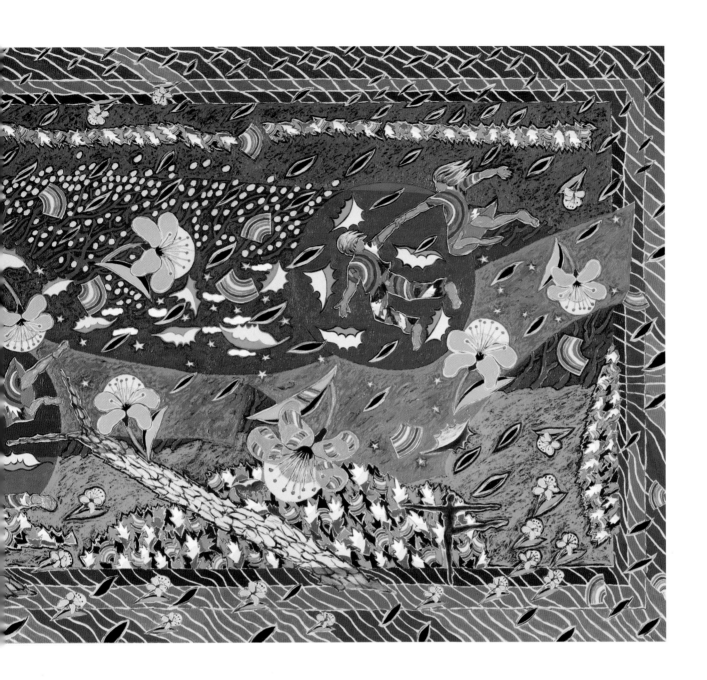

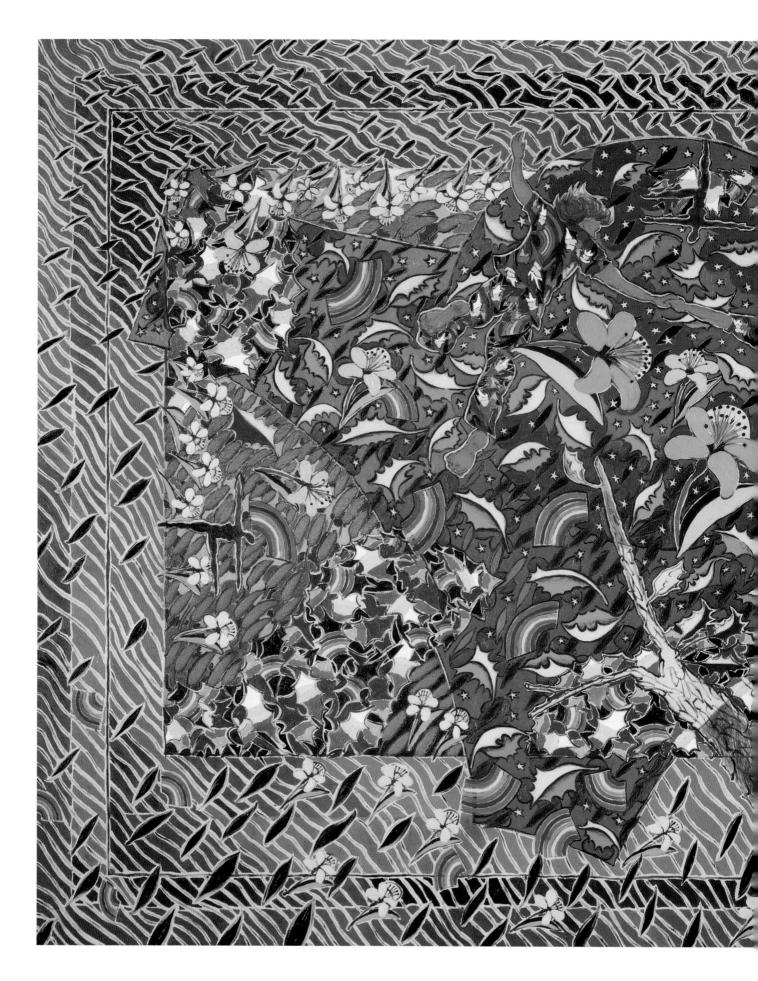

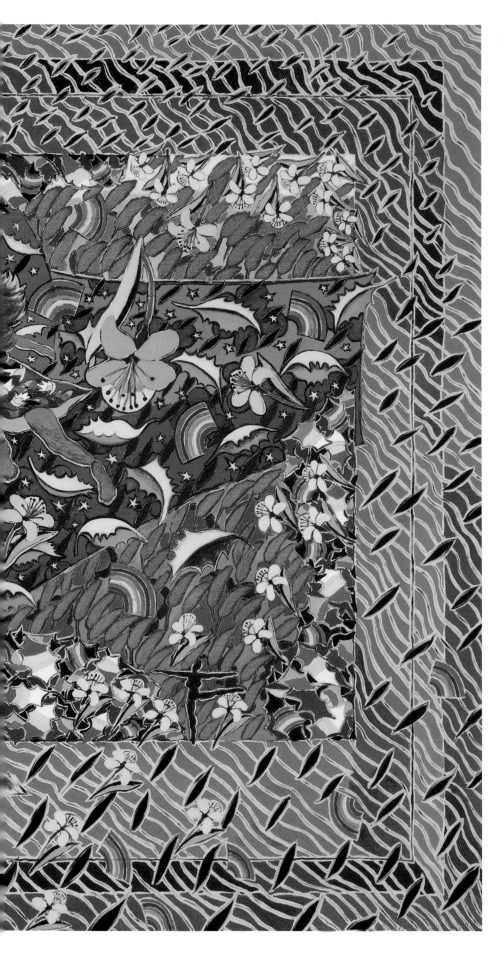

Music for Hymn to The Immortal
Wind(1108)
259.1×193.9cm
Oil on Canvas 2011

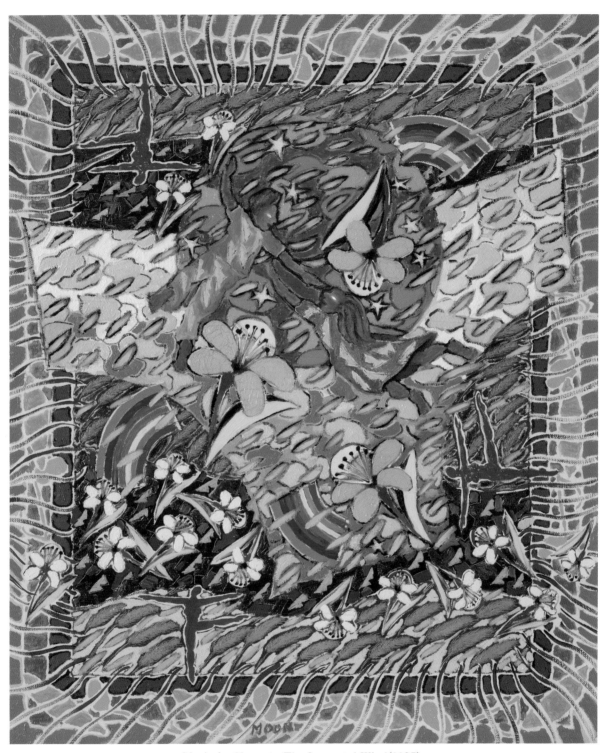

Music for Hymn to The Immortal Wind(1105)
65.1×53cm Oil on Canvas 2011

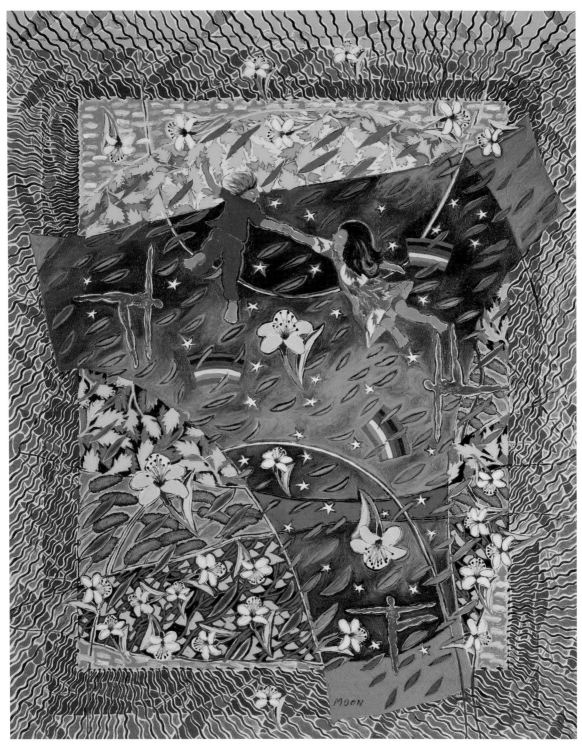

Music for Hymn to The Immortal Wind(1103)
162.2×130.3cm Oil on Canvas 2011

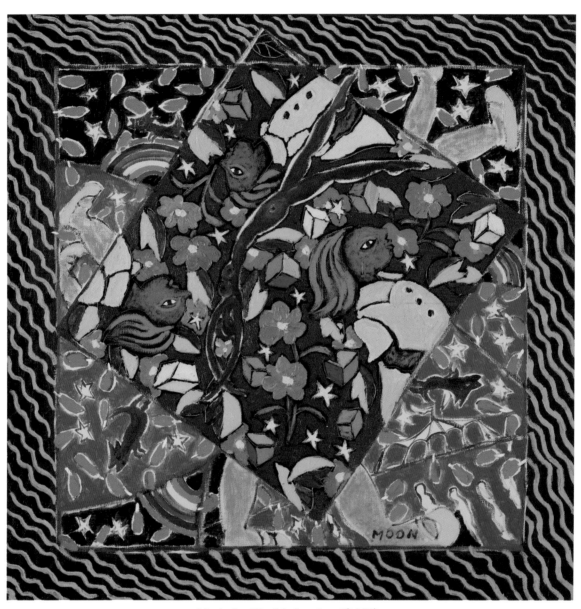

Music for The Lie Lay Land(1001)
55×55cm Oil on Canvas 2010

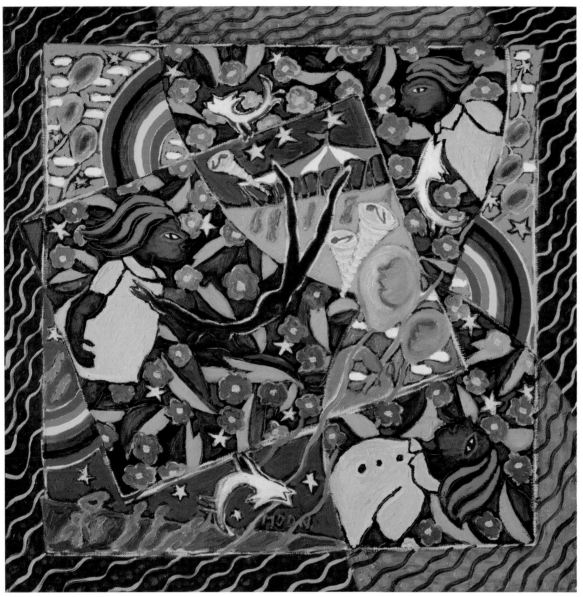

Music for The Lie Lay Land(1003)
55×55cm Oil on Canvas 2010

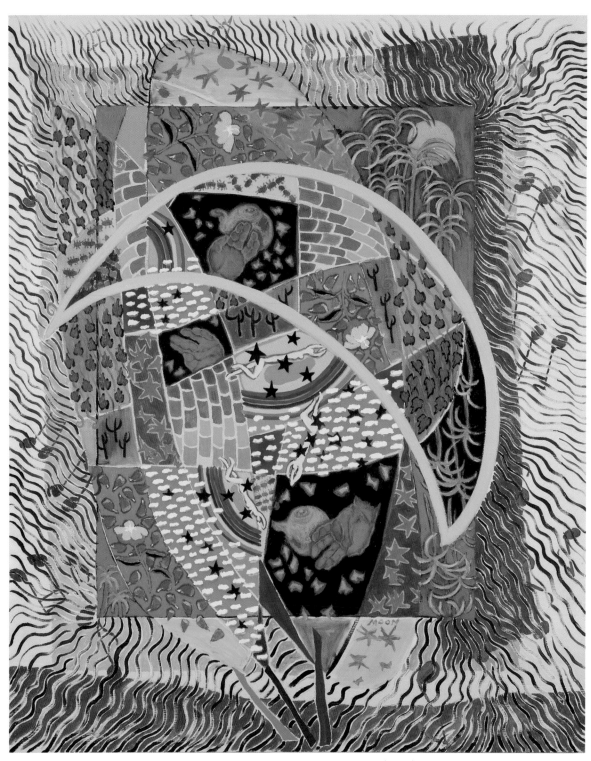

Music for Enchated Landscape Escape (0901)

162.2×130.3cm Oil on Canvas 2009

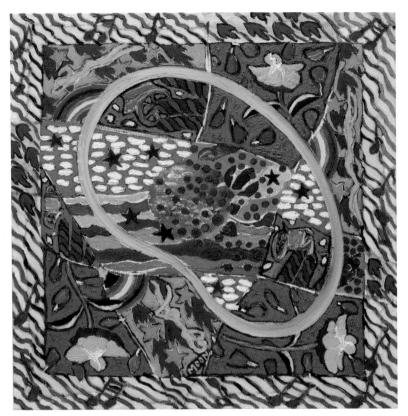

Music for Enchanted Landscape Escape(0907)
60×60cm Oil on Canvas 2009

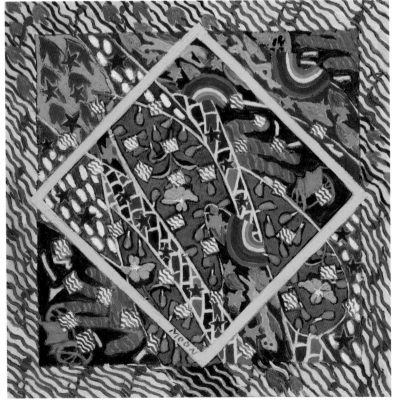

Music for Enchanted Landscape Escape(0908)
50×50cm Oil on Canvas 2009

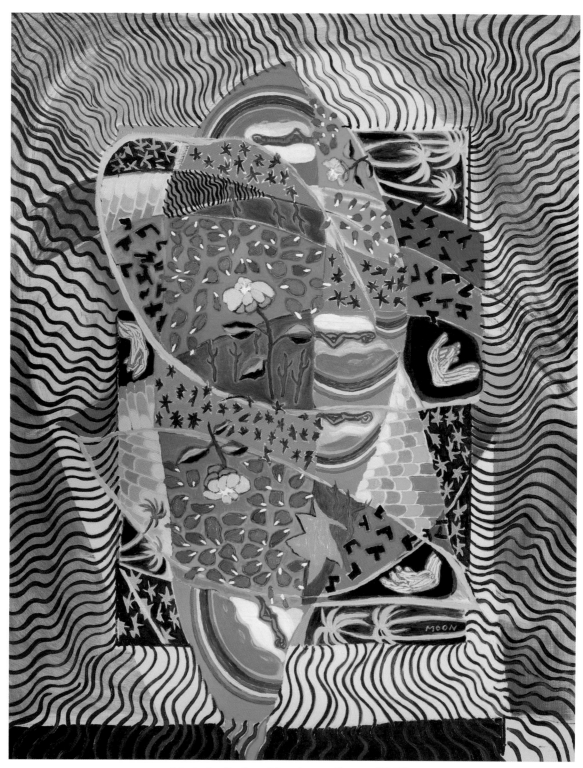

Music for Enchated Landscape Escape(0802)

162.2×130.3cm Oil on Canvas 2008

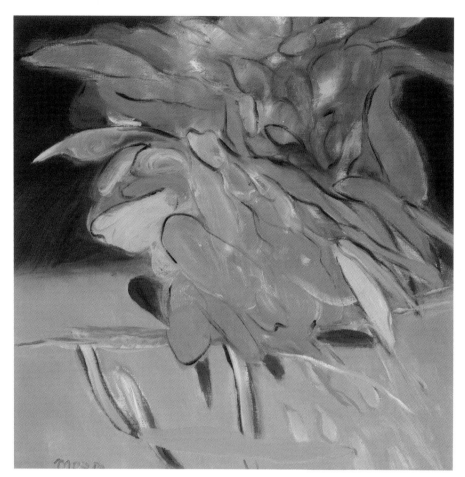

The Singer Bjork(0807)
90×90cm Oil on Canvas 2008

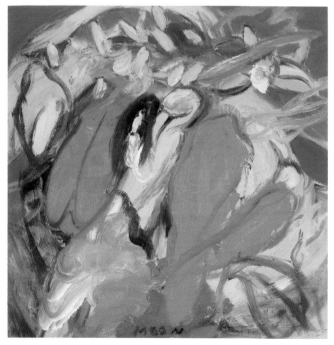

The Singer Bjork(0802)
40×40cm Oil on Canvas 2008

문혜자 (文惠子)

1945 부산출생 경남여고 졸업
　　　홍익대학교 조각과 및 성신여대 조각과 대학원 졸업,
　　　Studied Painting with Edie Read at Massachusetts Art College
1995 대한민국 미술대전 심사위원 역임
1997 대한민국 미술대전 운영위원 역임
1998. 2 ~ 2000. 2 서울특별시 예술장식품 심의위원 역임
2003 ~ 2006 시흥시 조형물 심의위원
2004 수원시 예술장식품 심의위원
2004 ~ 2005 서울특별시 예술장식품 심의위원 역임
2005 화성시 예술장식품 심의위원

개인전

2017. 12. 13 ~ 12. 31　ARTIFACT GALLERY(New York)
2015. 10. 21 ~ 11. 03　Lee Seoul 겔러리 , Seoul, Korea
2015. 03. 04 ~ 03. 22　ARTIFACT GALLERY(New York)
2012. 11. 14 ~ 11. 19　Insa Art Center , 서울
2011. 05. 04 ~ 05. 08　KOEX 전시장 RARE 겔러리, 서울
2010. 08. 24 ~ 09. 04　진화랑 진아트센터, 서울
2008. 11. 19 ~ 11. 25　인사아트센터, 서울
2007. 11. 13 ~ 11. 18　국제 인천 여성 미술 비엔날레, 인천
2007. 04. 20 ~ 04. 30　청화랑 갤러리, 서울
2007. 02. 03 ~ 02. 19　So − Un International Art Zofingen, Switzerland
2006. 04. 11 ~ 04. 21　진화랑 · 진아트센타, 서울
2005. 10. 13 ~ 10. 16　Kongresshaus Zurich, Switzerland
2004. 10. 14 ~ 10. 17　Kongresshaus Zurich, Switzerland
2004. 06. 18 ~ 07. 10　Agora Gallery(New York)
2002. 10. 23 ~ 11. 04　갤러리 썬앤문, 서울
2000. 04. 20 ~ 04. 29　갤러리 퓨전, 서울
1998. 04. 15 ~ 04. 29　썬앤문 화랑, 서울
1994. 06. 24 ~ 07. 22　캐나다 데오도르 미술관, Canada, Toronto
1993. 08. 20 ~ 08. 29　예술의전당 미술관, 서울
1992. 11. 03 ~ 11. 14　진아트센타, 진화랑, 서울
1990. 08. 29 ~ 09. 04　금호미술관, 서울
1987. 11. 06 ~ 11. 11　그로리치 화랑, 서울
1985. 11. 22 ~ 11. 29　경인미술관, 서울
1983. 06. 29 ~ 07. 04　롯데화랑, 서울
1981. 12. 04 ~ 12. 09　문예진흥원 미술회관, 서울
1980. 05. 01 ~ 05. 07　문예진흥원 미술회관, 서울

수 상

2018 한국미술관 초대작가상 수상
2010 서울신문사 주관 한국 경영혁신 예술부분 대상 수상
2008 Premio Ercole D'Este 수상(이태리)
2005 제216회 Unives des Arts Le Salon 2005 당선(프랑스 파리)
1982 대한민국미술대전 입선
1981 중앙미술대상전 특선

1966 대한민국 미술대전 입선
1965 대한민국 미술대전 입선
1965 신인 예술상전 입선

주요 전시(2018~1988)

2018. 06. 12 ~ 06. 18　SCOPE BASEL
2017. 12. 27 ~ 2018. 01. 02 새해를 맞으며 (한국미술관)
2017. 11. 22 ~ 11. 28 한국 미술협회 임원 초대전(한국미술관)
2017. 09. 21 ~ 09. 24　KIAF Art Seoul COEX, Seoul,Korea
2017. 04. 20 ~ 04. 24 BAMA_부산 인터내셔널 아트 페어(부산 BEXCO)
2017. 03. 24 ~ 03. 26 Harbour 아트 페어(홍콩)
2017. 02. 01 ~ 02. 10 MD jOURNAL 표지작가전 LeeSeoul 갤러리, Seoul
2016. 10. 12 ~ 10. 16 KIAF 2016/ART SEOUL COEX HALL A&B,SEOUL
2016. 06. 15 ~ 06. 18 The Korean Contemporary Art Show(NEPAL ART
　　　COUNCIL)
2015. 10. 07 ~ 10. 11 KIAF(PICI겔러리 초대) KOEX, Seoul,Korea
2015. 03. 05 ~ 03. 08 CONTEMPORARY IN NOVOTEL SUWON
　　　[NOVOTEL SUWON,(Suwon, korea)]
2014. 11. 12~11. 16 대구아트페어(대구EXCO)
2014. 9. 26 ~ 2015. 3.1 사유로서의 형식-드로잉의 재발견전(뮤지엄산 초대전)
2014 ARTSHOW BUSAN(BEXCO, BUSAN) Lee Seoul 겔러리 초대)
2013 홍익 63 Art(호서겔러리초대)
2013 2013 KIAF(PICI Gallery 초대)
2013 Korean Stance by International Artists(VanSingel Fine Arts Center,
　　　Grand Rapids, Michigan, U.S.A)
2013 양평군립미술관 초대전
2013 Pool Art Fair(New York)
2013 The Amory Show(New York)
2012 뉴욕 부로드웨이 겔러리 초대전
2012 바움겔러리 초대 아시이전
2011 홍익아트 63(인사겔러리 초대)
2011 SOAF 겔러리 RARE 초대(COEX, Seoul)
2011 Beijing Collection 2011(Beijing Artists Space, Beijing)
2011 February Group exhibition at Artists Haven Gallery(U.S.A.)
2010 Artists At Home & Abroad(Broadway Gallery, Broadway, New York)
2010 광주 국제 아트페어
2010 한국 여성미술 100년전 초대(이형 겔러리)
2010 선화랑초대 330인 스타전 초대
2009 KIAF 진화랑초대
2009 Imaginary Journey(Italy)
2008 Traces of Memory(Italy)
2007 국제 인천 여성 미술 비엔날레
2006 Sprit, The Spirite in Art(Italy)
2006 Magic The Magic Paths of Art(Estense Castle Ferrara, Italy)
2006 Verve and Reverence(a collective exhibition) Agora Gallery Chelsea,
　　　New York
2006 Singapore International Art Fair

2005 Primal Perspectives – Agora Gallery(NewYork)
 Candance Marquette, Catherine Anne Towns,
 Hye Ja Moon, Karen Schnepf, Maria Luisa Persson
2005 China International Gallery Exposition – Beijing world trade center
2005 Zurich International
 Contemporary Art Fair(Zurich, Switzerland)
2004 Han River Art Forum(GALERIE PICI)
2004 Zurich International Contemporary Art Fair(Zurich, Swizterland)
2003 Agora Gallery 4인전(NewYork)
 C.ALI, HyeJa Moon, ROGER McCLUNG,SEBASTAN MARQUEZ
2002 Abstract Perspectives(Agora Gallery, NewYork)
2001 200 Artist's Small Exhibition(선 화랑)
2001 갤러리 La Mer 개관기념초대전(갤러리 La Mer)
2000 Structures – Agora Gallery(NewYork)
2000 갤러리 Wing 개관기념 조각 초대전(갤러리 Wing)
2000 ART-EXPO On-Line전(New York City's Jacob Javitz Center, March
 9~13, 2000)
2000 International Women Artists(La Galerie Internationale, Palo Alto,
 CA. U.S.A)
1999 음악이 있는 두 개의 공간전(인사 갤러리)
1999 제9회 청담 미술제(청화랑)
1999 Beyond Stage전(국립극장)
1999 Visible Music전 – Agora Gallery Soho(NewYork)
1998 Second International Women Artists Festival
 (The Firehouse at Fort Mason Center San Francisco, U.S.A.)
1998 International Women Artists(La Galerie Internationale Palo Alto, CA
 U.S.A.)
1997 World's Women On-Line전(Arizona State University, U.S.A.)
1997 광주 비엔날레 특별전(광주 중외공원)
1996 한국 현대미술 현재와 미래전(홍익대학교 현대미술관)
1996 한국 현대미술 현상과 전망(수원대학교 고운미술관)
1995 인사갤러리 개관 1주년 기념초대전(인사갤러리)
1994 서울정도 600주년 기념초대전(예술의전당)
1994 헝가리 타다 국제조형전 참가(Tata, Hungary)
1994 음악과 무용의 미술전(예술의전당)
1994 EXPO 촉각조각전(대전 EXPO 전시장)
1993 '93 Air Fair 참가(예술의전당)
1992 IAA 국제조형전(예술의전당)
1990 맥 조각전 – Simonson Gallery(La, U.S.A.)
1990 예술의전당 개관기념 초대전(예술의전당)
1985 ~ 1992 한국 현대미술 초대전(국립현대미술관)
1989 '80년대 여성 미술전(금호 미술관)
1988 '88올림픽 현대미술초대전(국립현대미술관)
1988 한불 조각가 초대전(Paris, France)

공공기관 작품소장

2011 Golden Sky International Hotel&Resort

2010 "To The Stars"(장안대학교)
2009 "Music for Enchanted Landscape Escape" 서울 시립미술관
2001 'The fantasy of jazz 98-1' 강원도 삼척시 국립공원
1996 '죽엄과 변용 R.스트라우스 작곡
 (Symphony Poem tod und Verklarung Op.24)'
 홍익대학교 현대미술관
1996 '슬픈 음악의 심포니 헨리크 고레기 작곡(Symphony of sorrowful Songs
 by Henrik Goreki)'
 수원대학교 고운미술관
1992 '피아노 협주곡 황제 베토벤 작곡
 (Piano Concert No.5 by Ludwig Van Beethoven)'
 현대영빈관
1991 '바이올린 협주곡 제 1번 막스 브루흐 작곡
 (Violin Concerto No.1 by Bruch, Max)'
 MBC 예술단
1990 '무지카 안디나 델 페루(Musica Andina del Peru)'
 금호미술관
1987 '대지(Good Earth)' 국립현대미술관
1978 '굴레(Annual Rings)' 용인 호암미술관

개인 소장

2010 브로드웨이 갤러리 베이징
2006 보스톤 대학 총장 저택에 작품소장
2007 스위스 소운 갤러리 작품소장

조형물 제작

1995 수원 갤러리아 백화점 조형물 제작
1994 한국통신 문산전화국 상징 조형물 제작
1993 한국냉장 본사 조형물 제작
1991 한국통신 대전연수원 조형물 제작
1991 경기도 체육회관 상징 조형물 제작
1990 오산시 상징 탑 제작(높이 12m)
1988 대구 프린스 호텔 내부장식 부조 및 환조

3권의 수필집 출간 : 흐름(1991), 도심의 구두 수선 집(1992), Deep Blue(1995)

1980 ~ 2010 장안대학교 교수
1998 ~ 2006 미국 뉴욕 Agora Galery Representative 작가

이태리 TIA 회원
2010~2012 미국 뉴욕 Broadway Gallery 작가,
미국 뉴욕 Gallery ARTIFACT 작가

HYE JA MOON

Born in Pusan, Korea, in 1945
Dept.of Sculpture, Fine Art College, Hongik University(B.F.A)
M.F.A at Sung-Shin Women's University(M.F.A)
Studied Painting with Edie Read at Massachusetts Art College
Served as a juror for Korea Art Competition
Operation Member for the Seoul City Juried Art Decoration(1998-2000)
Operation Member for the Siehung City Juried Art Decoration(2003-2006)
Operation Member for the Su-won City Juried Art Decoration(2004)
Operation Member for the Seoul City Juried Art Decoration(2004-2005)
Operation Member for the HwaSeong City Juried Art Decoration(2005)

Solo Exhibitions

2017. 12. 13 ~ 12. 31 ARTIFACT GALLERY(New York)
2015. 10. 21 ~ 11. 03 Lee Seoul Gallery, Seoul, Korea
2015. 03. 04 ~ 03. 22 ARTIFACT GALLERY(New York)
2012. 11. 14 ~ 11. 19 Insa Art Center, Seoul, Korea
2011. 05. 04 ~ 05. 08 KOEX Exhibition Hall, Seoul, Korea
2010. 08. 24 ~ 09. 04 Jean Art Galleruy, Jean Art Center, Seoul, Korea
2008. 11. 19 ~ 11. 25 INSA Art Center, Seoul, Korea
2007. 11. 13 ~ 11. 18 International Incheon Women Biennale, Incheon, Korea
2007. 04. 20 ~ 04. 30 Chung Art Gallery Seoul, Korea
2007. 02. 03 ~ 02. 19 So - Un International Art Zofingen, Switzerland
2006. 04. 11 ~ 04. 21 Jean Art Gallery .Jean Art Center Seoul, Korea
2005. 10. 13 ~ 10. 16 Kongresshaus Zurich, Switzerland
2004. 10. 15 ~ 10. 17 Kongresshaus Zurich, Switzerland
2004. 06. 18 ~ 07. 10 Agora Gallery, Soho, New York
2002. 10. 23 ~ 11. 04 Gallery Sun & Moon, Seoul, Korea
2000. 04. 20 ~ 04. 29 Gallery Fusion, Seoul, Korea
1998. 04. 15 ~ 04. 29 Sun & Moon Gallery, Seoul, Korea
1994. 06. 24 ~ 07. 22 Theodore Museum of Contemporary Art, Toronto, Canada
1992. 11. 03 ~ 11. 14 Jin Art Gallery, Jin Art Center, Seoul, Korea
1993. 08. 20 ~ 08. 29 Seoul Arts Center, Seou, Koreal
1990. 08. 29 ~ 09. 04 Keum-Ho Museum, Seoul, Korea
1987. 11. 06 ~ 11. 11 Growrich Gallery, Seoul, Korea
1985. 11. 22 ~ 11. 29 Kyung-In Museum, Seoul, Korea
1983. 06. 29 ~ 07. 04 Lotte Gallery, Seoul , Korea
1981. 12. 04 ~ 12. 09 Art Center, The Korean Culture and Arts Foundation, Seoul, Korea
1980. 05. 01 ~ 05. 07 Art Center, The Korean Culture and Arts Foundation, Seoul, Korea

Award

2018 Invited Artist Award(Korea Museum)
2010 Won a Prize from Seoul Newspaper
2008 Won a Prize Premio Ercole D'Este(Italy)
2005 Chosen 216times Unives des Arts Le Salon 2005(Paris,France)
1982 The winner of Korea National Art competion
1980 The Winner of Chung-Ang Art competition
1981 Special Prize , Chung-Ang Art competitipn
1966 The Winner of Korea National Art competition
1965 The winner of New figure Artist`s prize
1965 The winner of Korea National Art competition

Major Exhibitions(2018~1988)

2018. 06. 12 ~ 06. 18 SCOPE BASEL
2017. 12. 27 ~ 2018. 01. 02 The New Year Korea museum
2017 The Invitational Exhibition of KFAA Execultives Nobemver 22-28 Korea museum
 KIAF 2017 ART SEOUL 21-24 September Coex Hall
2017. 04. 20 ~ 04. 24 BAMA_Busan International Art Fair(Busan BEXCO)
2017. 03. 24 ~ 03. 26 Harbour Art Fair(Hong Kong)
2017. 02. 01 ~ 02. 10 The artists of the MD JOURNAL cover paintings(LeeSeoul Gallery, Seoul)
 KIAF 2016/ART SEOUL COEX HALL A&B, SEOUL 12-16 OCT, 2016
2016 The Korean Contemporary Art Show 15-18 June,2016(NEPAL ART COUNCIL)
2015. 10. 07 ~ 10. 11 KIAF(PICI Gallery) KOEX, Seoul,Korea
2015. 03. 05 ~ 03. 08 CONTEMPORARY IN NOVOTEL SUWON [NOVOTEL SUWON,(Suwon, korea)]
2014. 11. 12 ~ 11. 16 Daegu Artfair(Daegu Exco, KOREA)
2014. 9. 26 ~ 2015. 3. 1 FROM AS THINKINGH-REDISCOVERY OF DRAWING(MUSEUM SAN), KOREA
2014 ARTSHOWBUSAN 2014(BEXCO, BUSAN, KOREA)
2013 Hongik Art 63(Hoseo Gallery)
2013 KIAF(PICI Gallery)
2013 Korean Stance by International Artists(VanSingel Fine Arts Center, Grand Rapids, Michigan, U.S.A)
2013 Yang Pyeung Museum(Seoul, Korea)
2013 Pool Art Fair(New York)
2013 The Amory Show(New York)
2012 ARTIST AT HOME AND ABROAD(Broadway Gallery in New York)
2012 Asia Exhibition(Baum Art Gallery, Seoul)
2011 Hongik Art 63(Insa Gllery, Seoul)
2011 SOAF(COEX, Seoul)
2011 Beijing Collection 2011(Beijing Artists Space, Beijing)
2011 February Group Exhibition at Artists Haven Gallery(U.S.A)
2010 Artists At Home & Abroad(Broadway Gallery Broadway, New York)
2010 Gwang Ju International Art Fair Gwang Ju, Korea
2010 Blockbuster of Woman(Yi Hyung Gallery) Seoul, Korea
2010 The more, The better (Sun Gallery.Sun Art Center) Seoul, Korea
2009 KIAF Seoul, Korea
2009 Imaginary Journey, Italy
2008 Traces of Memory, Italy
2007 International Incheon Women Biennale, Incheon, Korea
2007 Spirit The Spirit in Art, Italy
2006 Magic The Magic Paths of Art, Italy
2006 Singapore International Art Fair, Singapore
2005 Primal Perspectives - Agora Gallery(New York)
2005 China International Gallery Exposition(Beijing world trade center), China

2005 Zurich International Contemporary Art Fair(Zurich, Switzerland)
2005 Korea Art Festival(SEJONG CENTER) Seoul, Korea
2004 Exhibition of Tunisia, Tunisia
2004 Zurich International Contemporary Art Fair(Zurich, Switzerland)
2004 Exhibition of cosmos gallery Seoul, Korea
2004 Exhibition of yeil gallery Seoul, Korea
2004 HAN RIVER ART FORUM(GALERIE PICI) Seoul, Korea
2003 Exhibition of Sungshin(Sungshin Museum) Seoul, Korea
2003 Abstract perspectives(Agora Gallery, New York
2002 Meeting Exhibition by a favorite work of mine and Favorite Artist's
 work,(Suwon Arts center) Seoul, Korea
2002 Abstract Perspectives(Agora Gallery, New York)
2001 200 Artist's Small Sculpture Exhibition(Sun Gallery) Seoul, Korea
2001 Celebrating Exhibition for Opening of Gallery La Mer(Gallery La
 Mer) Seoul, Korea
2000 Structures(Agora Gallery, New York))
2000 ART-EXPO On Line!, Jacob's Javitz Center, New York City
2000 International Women Artists(La Galerie Internationale, Palo Alto,
 CA, U.S.A.)
1999 Tow-Space with Music(Insa Gallery) Seoul, Korea
1999 Seoul The 9 th Chungdam Art Fair(supported by Chung Gallery)
 Seoul, Korea
1999 Beyond Stage(The National Theatre) Seoul, Korea
1999 Visible Music(Agora Gallery, New York)
1998 The 2 nd International Women Artists' Festival
 (The Firehouse at Fort Mason Center, San Francisco, U.S.A.)
1998 International Women Artists
 (La Galerie Internationale, Palo Alto, CA, U.S.A.)
1997 World's Women On Line!(Arizona State University, U.S.A.)
1997 Special Exhibition, Kwangju Biennale(Choong-Whae Park, Kwangju)
 Kwangiu, Korea
1996 The Present and Future of Korean Contemporary Art
 (Museum of Contemporary Art, Hong-Ik University) Seoul, Korea
1996 The Situation and Prospect on the Korean Contemporary Art
 (Koun Art Museum, Suwon University) Seoul, Korea
1995 Invited Exhibition for the 1st Anniversary of Insa Gallery(Insa
 Gallery) Seoul, Korea
1994 Invited Exhibition for the 600th Anniversary of Seoul(Seoul Arts
 Center) Seoul, Korea
1994 Participated in Tata International Art Exhibition(Tata, Hungary)
1994 Art Exhibition with Music and Dance(Seoul Arts Center) Seoul,
 Korea
1994 Tactile Sculpture EXPO(Daejun EXPO) Daejun, Korea
1993 Daejun '93 Art Fair(Seoul Arts Center)
1992 IAA International Art Exhibition(Seoul Arts Center) Seoul, Korea
1990 Mac Sculpture Exhibition(Simonson Gallery, LA, U.S.A.)
1990 Celebrating Exhibition for Opening of Seoul Arts Center(Seoul Arts
 Center) Seoul, Korea
1985 ~ 1992 Invited Exhibition of Korean Contemporary Art
 (The National Museum of Contemporary Art) Seoul, Korea
1988 Women in 80s(Keum-Ho Museum) Seoul, Korea
1988 Invited Exhibition of Contemporary Art for '88 Olympics
 (The National Museum of Contemporary Art) Seoul, Korea

1988 Invited Exhibition of Korean-French Sculptors(Paris, France)

Public Collections

2011 Golden Sky International Hotel&Resort
2010 To The Stars(Jangan University)
2009 Music for Enchanted Landacape Escape(Seoul City Museum)
2001 The fantasy of jazz 98-1(The Seaside Sculpture Park in Samcheok
 City)
1996 Symphony of Sorrowful Songs by Henrik Goreki(Koun Museum,
 Suwon University)
1996 Symphony Poem Tod und Verklarung Op.24
 (The Museum of Contemporary Art Hong-Ik University, Seoul)
1991 Violin Concerto No.1 by Bruch, Max(MBC Arts Group)
1992 Piano Concert No.5 by Ludwig Van Beethoven(Hyundai reception
 hall)
1990 Musica Andina del Peru(Keum-Ho Museum)
1987 Good Earth(The National Museum of Contemporary Art, Kwachun)
1986 Pillar(Shinchunji Museum)
1978 Annual Rings(Hoam Museum, Yongin)

Private Collections

2010 Broadway Gallery in Beijing
2006 The residence of President of Boston University
2007 So-un Gallery, Zofingen, Switzerland

Monumental Work

1995 Galleria Department Store
1994 Dunsan Telephone Office
1993 The Korea Refrigerate Co.(Main Building)
1991 The Athletic Center, Kyungki-do
1991 The Training Institute of Korea Telecommunications, Daejun
1990 Column of the City, Osan
1988 Interior Relief in Prince Hotel, Daeku

Publications(Essays) Flows(1991), Shoe Repair Shop in the Heart of the
 City(1992), Deep Blue(1995)

1980 - 2010 Professor of Jangan University
1998 - 2006 Representative Artist for Agora Gallery, New York
Representative Artist of Gallery ARTIFACT in New York

The philosophy of offloading

2018년 10월 15일 초판 발행

발 행 인 최 석 로
발 행 처 서 문 당
주 소 경기도 고양시 일산서구 덕산로 99번길 85(가좌동 630)
우편번호 10204
전 화 (031) 923-8258
팩 스 (031) 923-8259
등록번호 제406-313-2001-000005호
창업일자 1968.12.24
ISBN 978-89-7243-688-1